Mom,
Happy Canada Day!

Love
Shelley

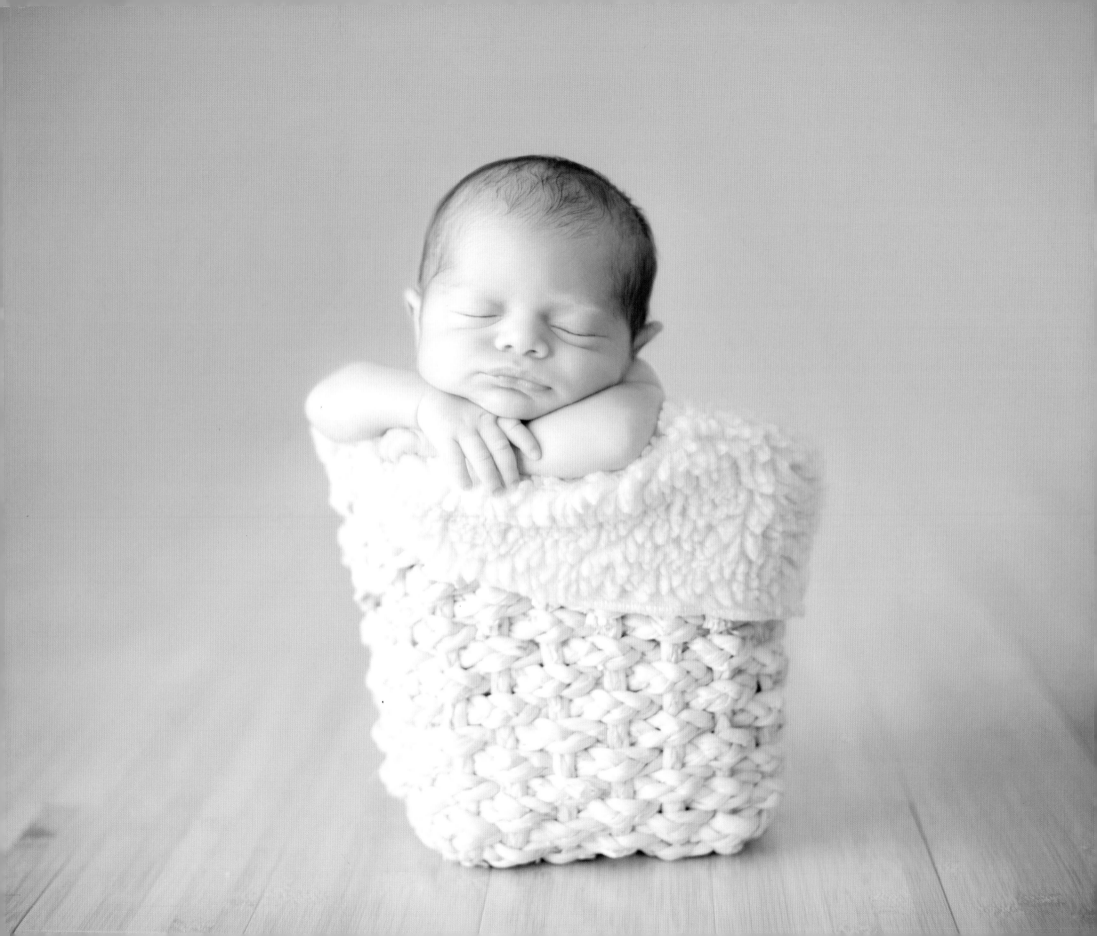

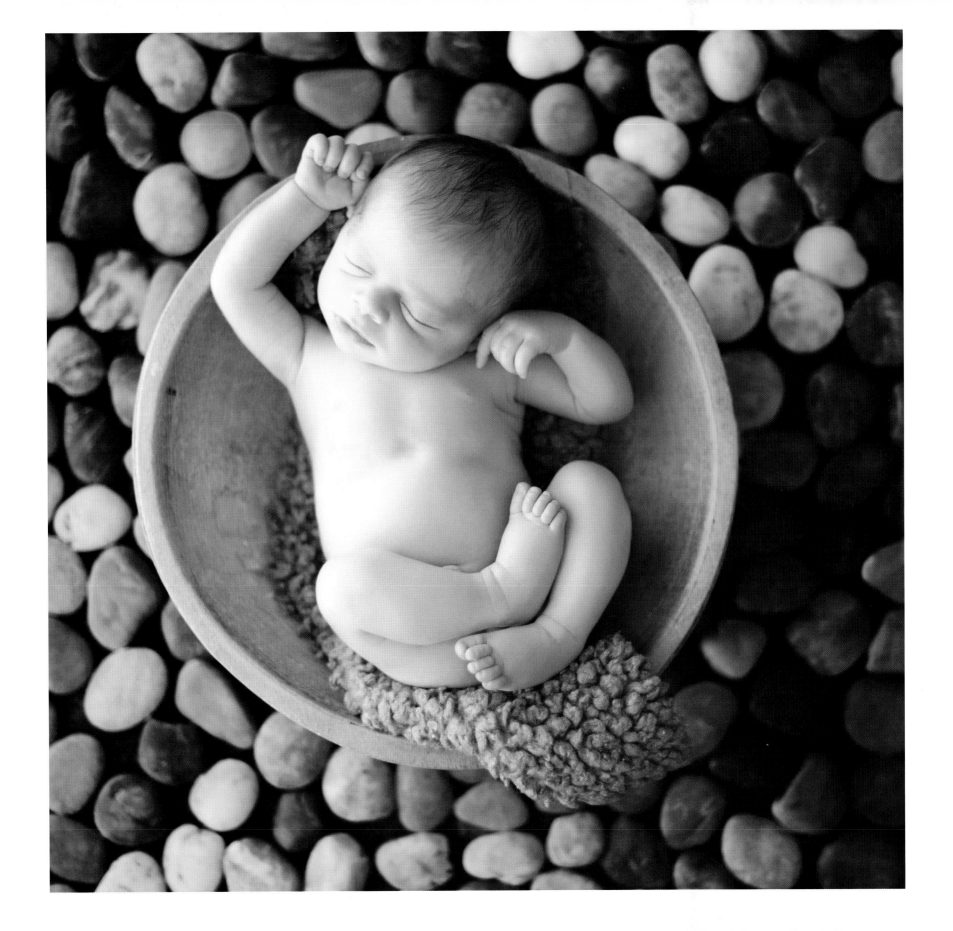

Published by Sellers Publishing, Inc.

Photography © 2010 Tracy Raver Photography, Kelley Ryden Photography

Sellers Publishing, Inc.
161 John Roberts Road, South Portland, Maine 04106
For ordering information:
(800) 625-3386 toll free
(207) 772-6814 fax
Visit our Web site: www.sellerspublishing.com
E-mail: rsp@rsvp.com

ISBN: 13: 978-1-4162-0577-7

10 9 8 7 6 5 4 3 2 1

Printed and bound in China.

Sleeping Beauties

NEWBORNS IN DREAMLAND

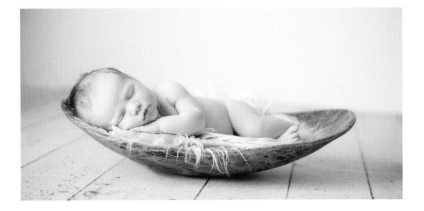

PHOTOGRAPHS BY

TRACY RAVER & KELLEY RYDEN

SELLERS PUBLISHING

Dedication

*To our supportive mother and
in loving memory of our father.*

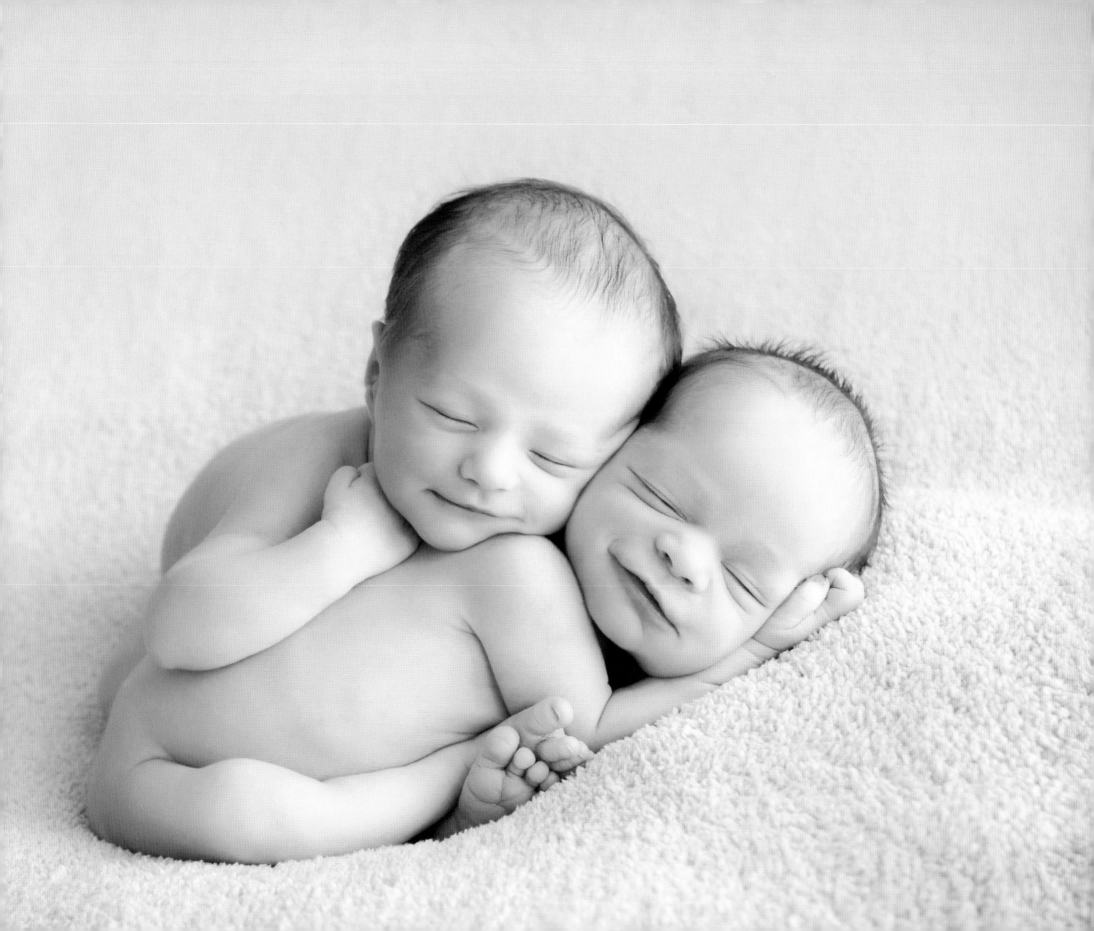

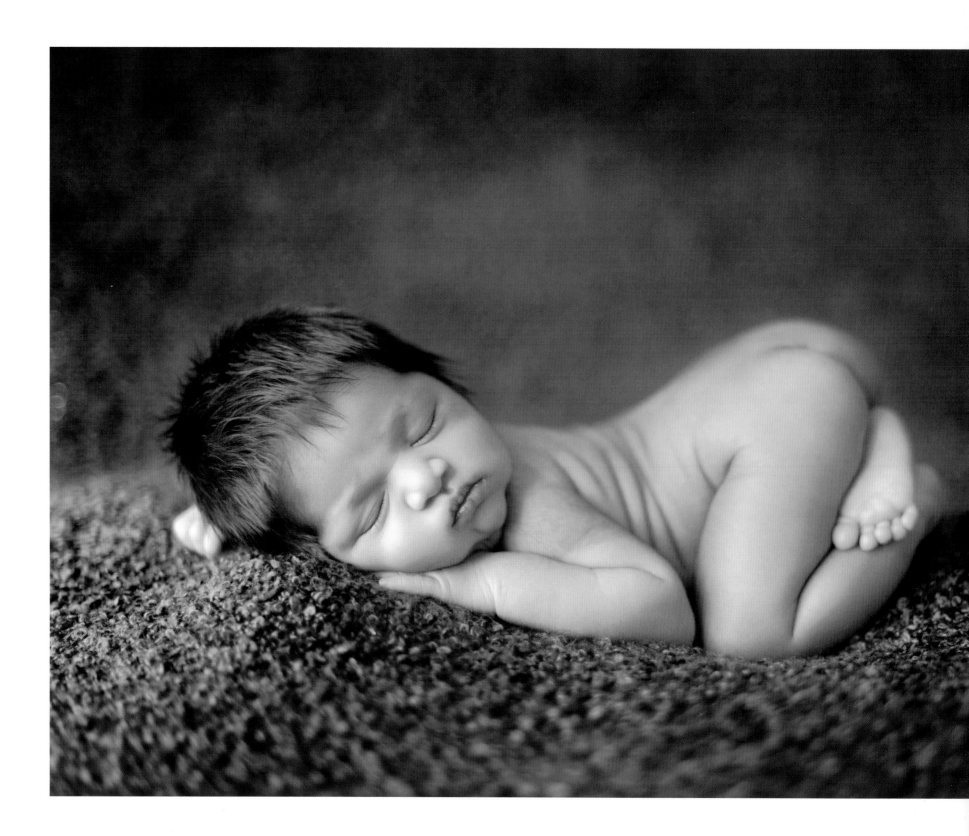

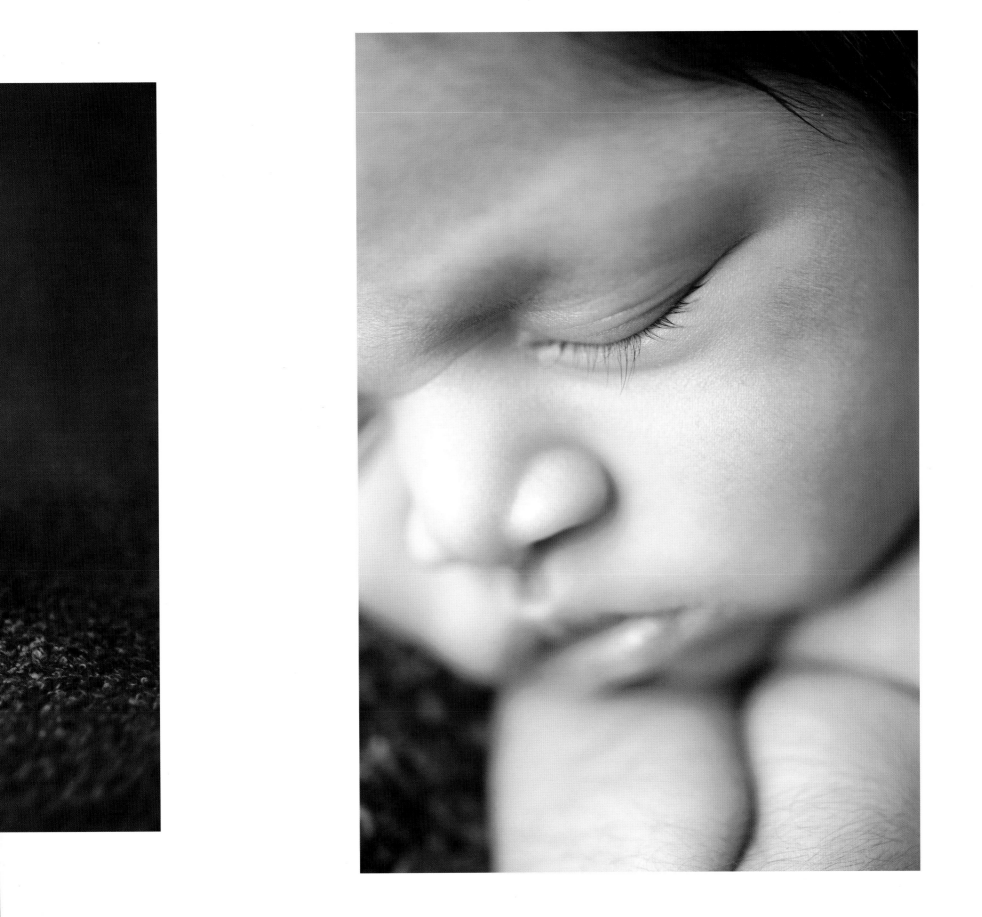

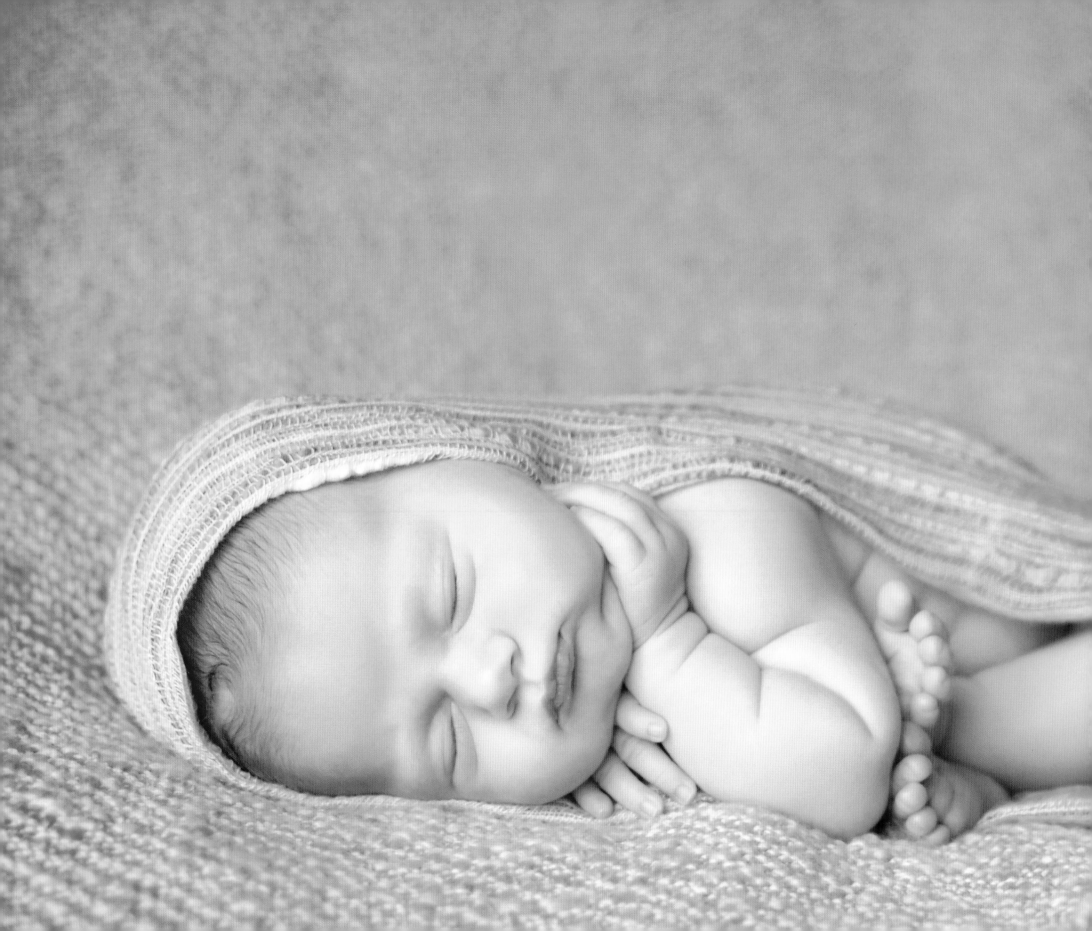

From small beginnings come great things.

— *Proverb*

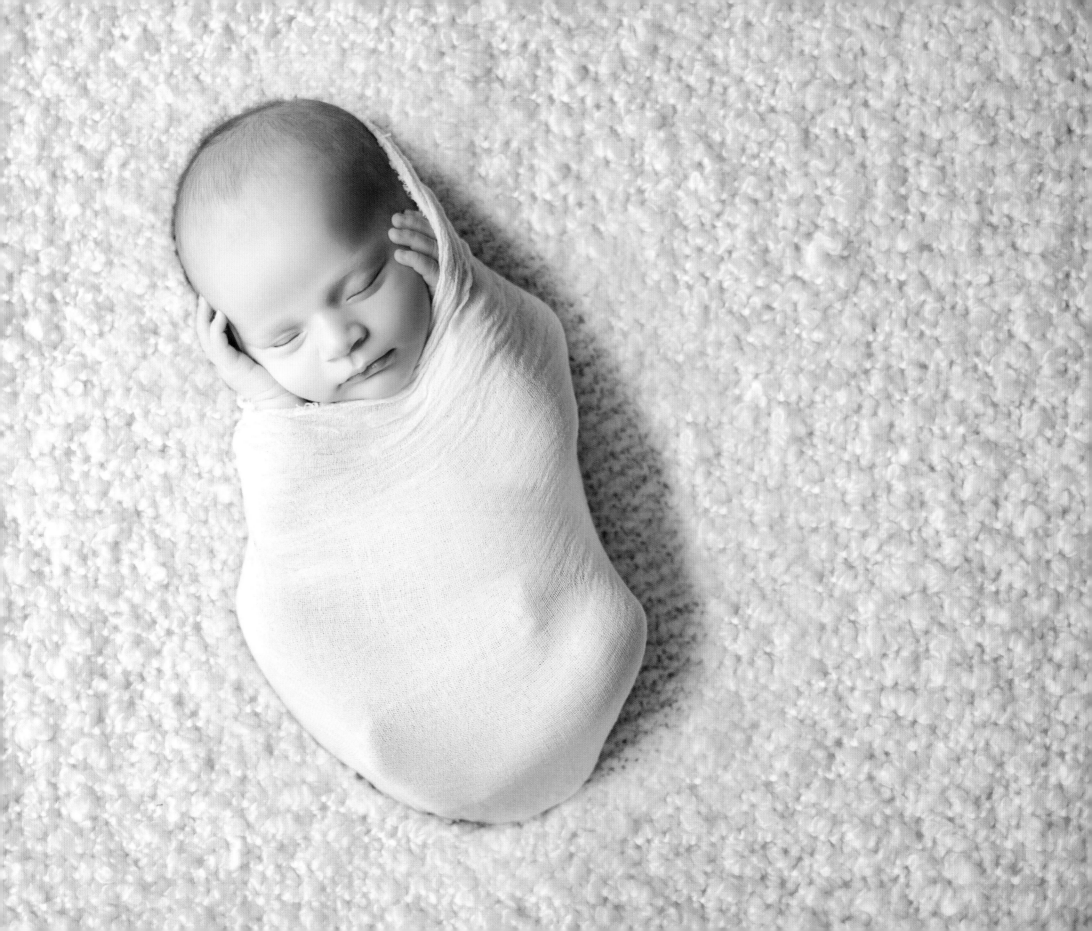

A newborn is the start of all things — hope,
and a dream of possibilities . . .

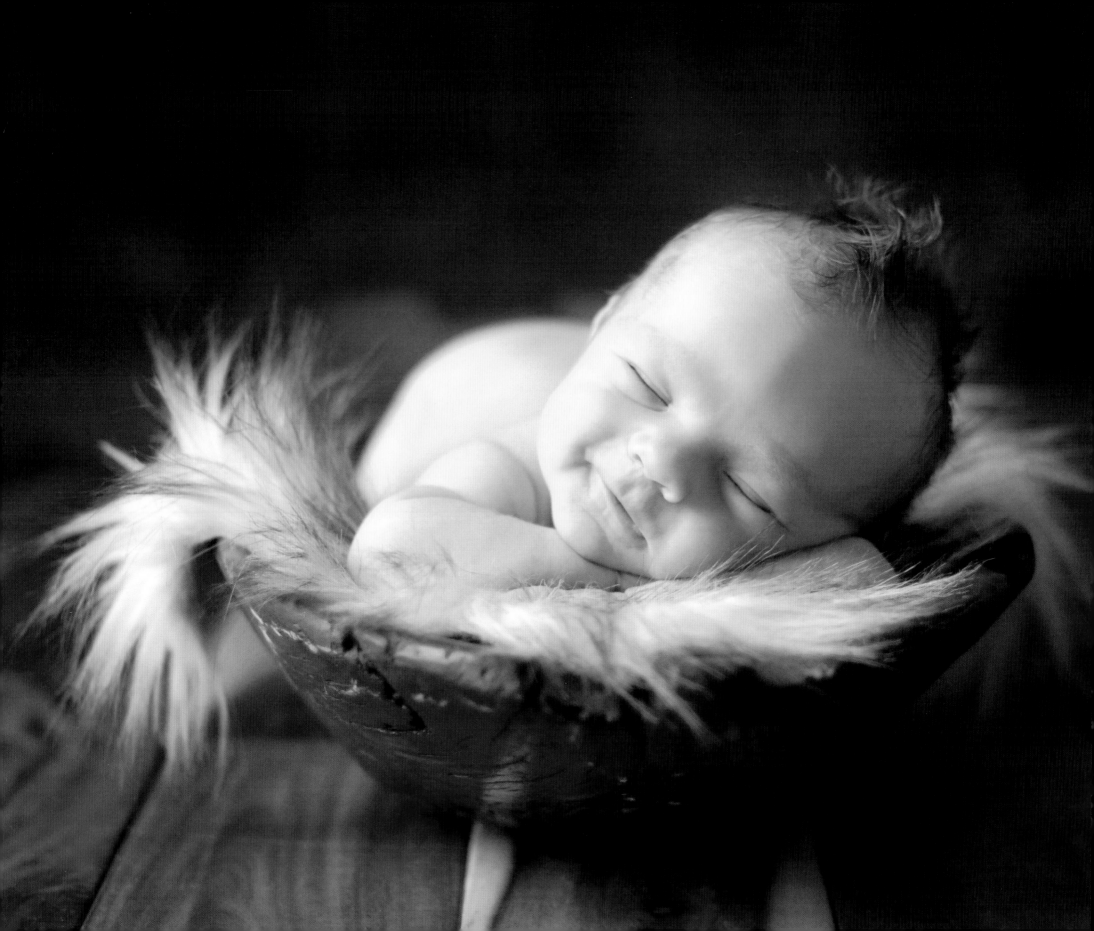

a sweet new blossom of humanity.

— *Anonymous*

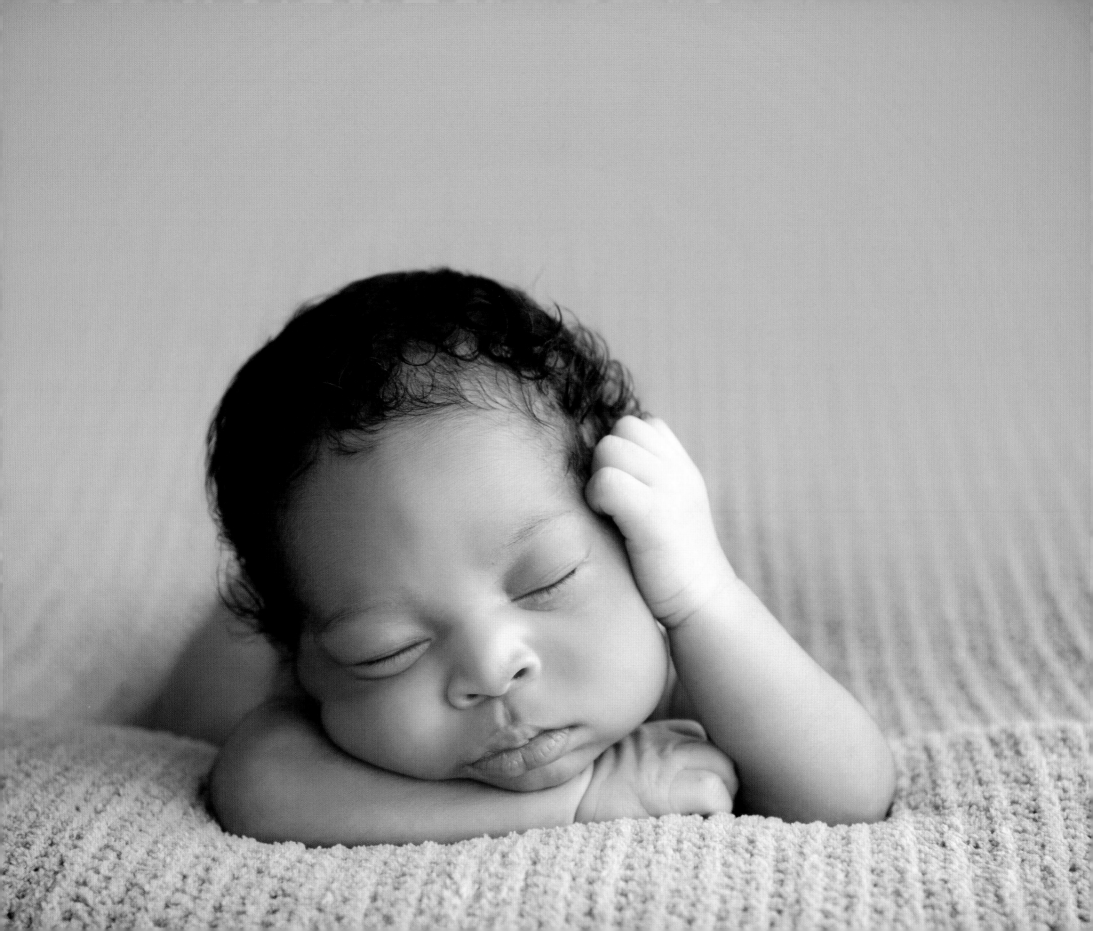

The beginning is the most important part, especially in the case of a young and tender thing; for that is the time at which the character is being formed.

— *Plato*

It is the sweet, simple things of life which are the real ones after all.

— Laura Ingalls Wilder

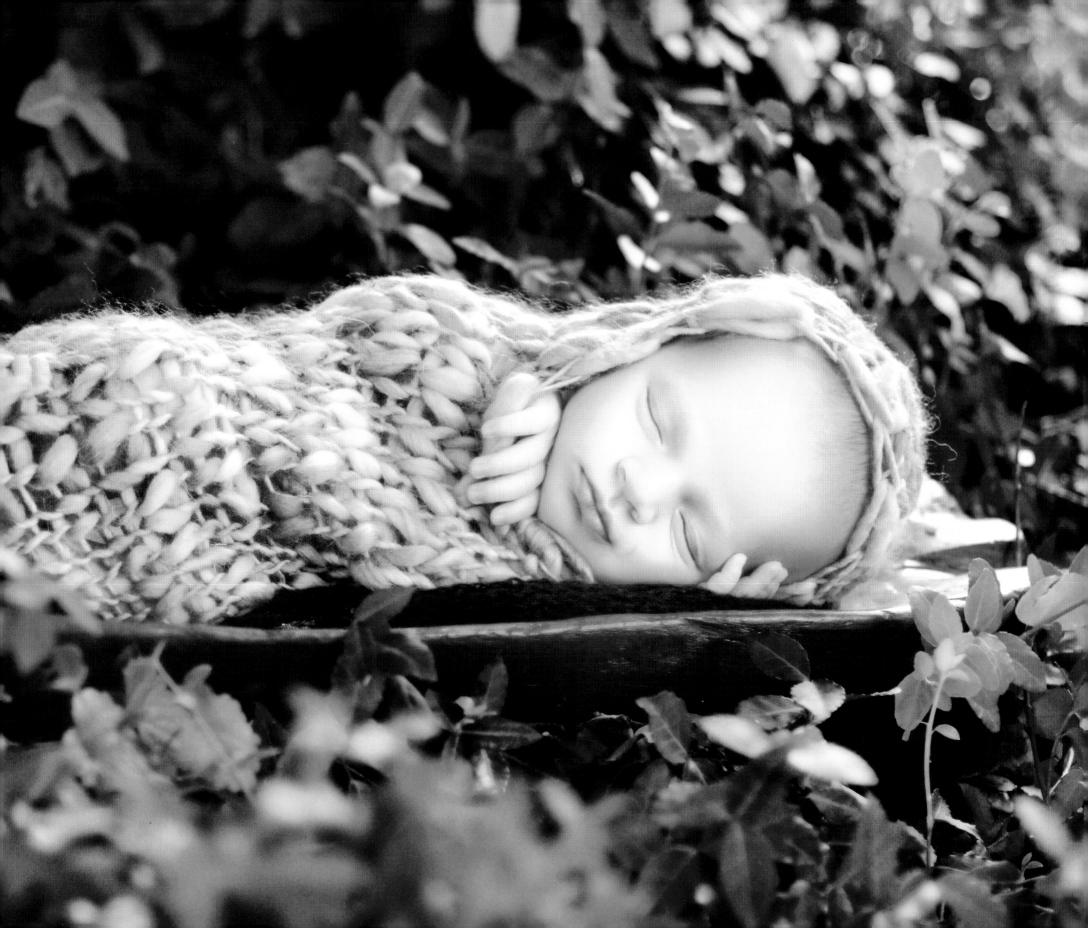

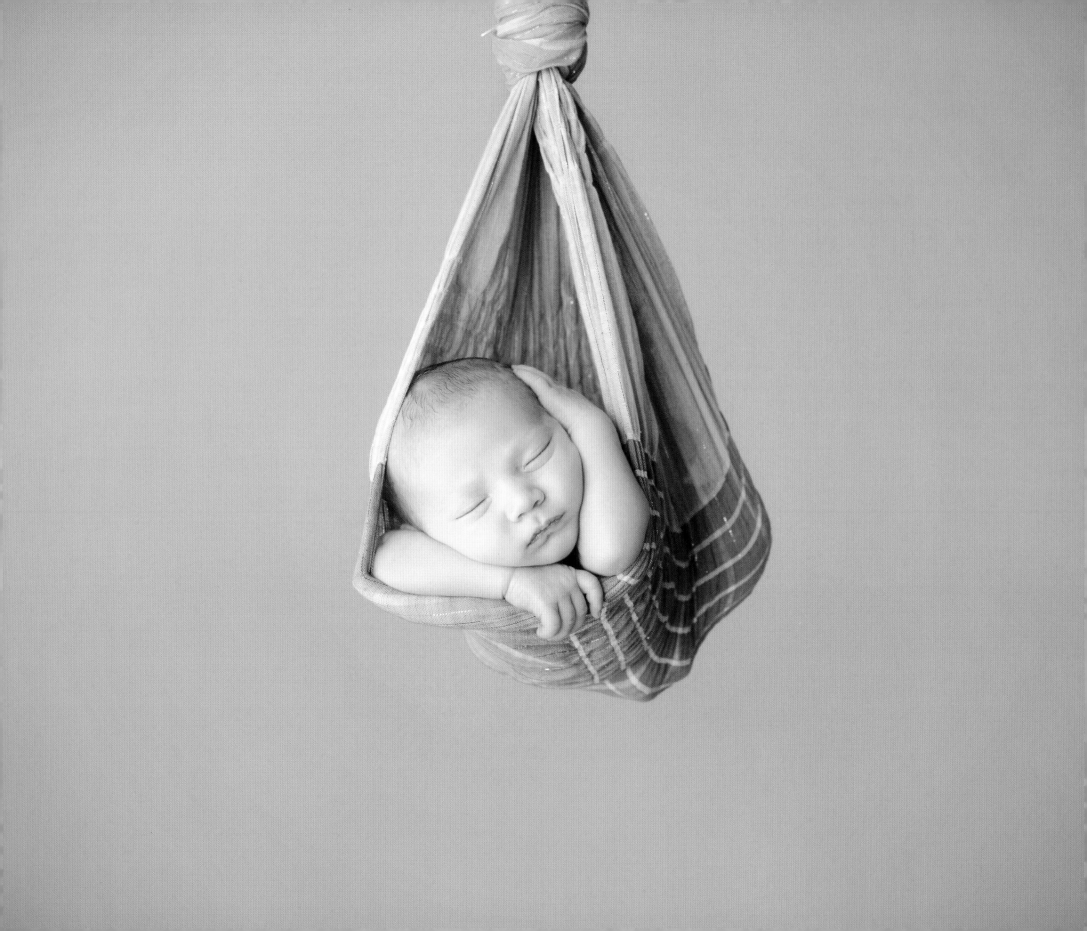

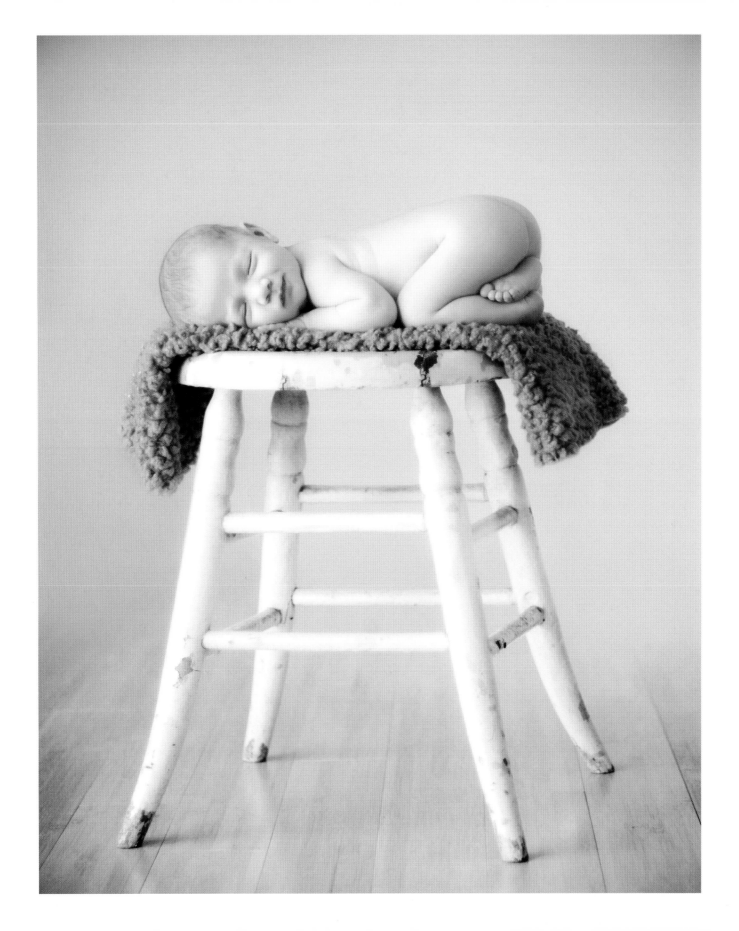

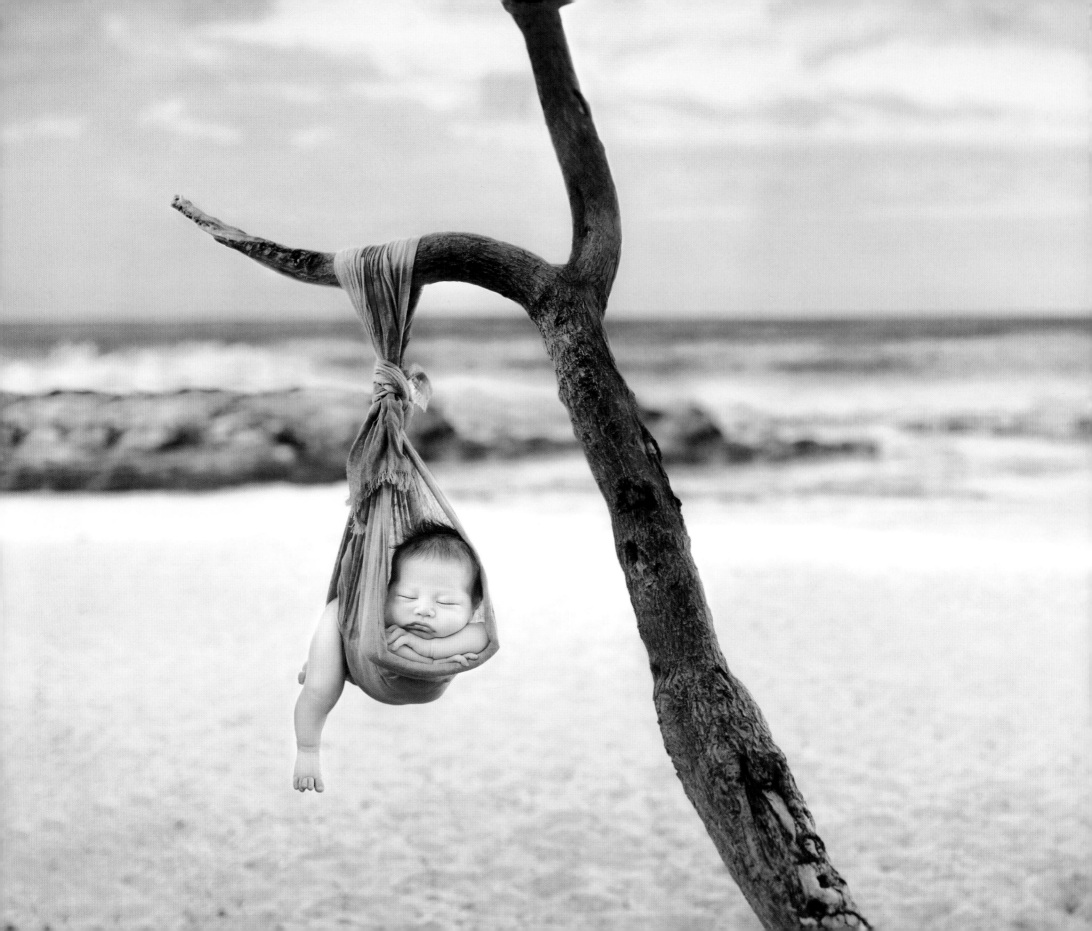

To love and be loved is to feel the sun from both sides.

— David Viscott

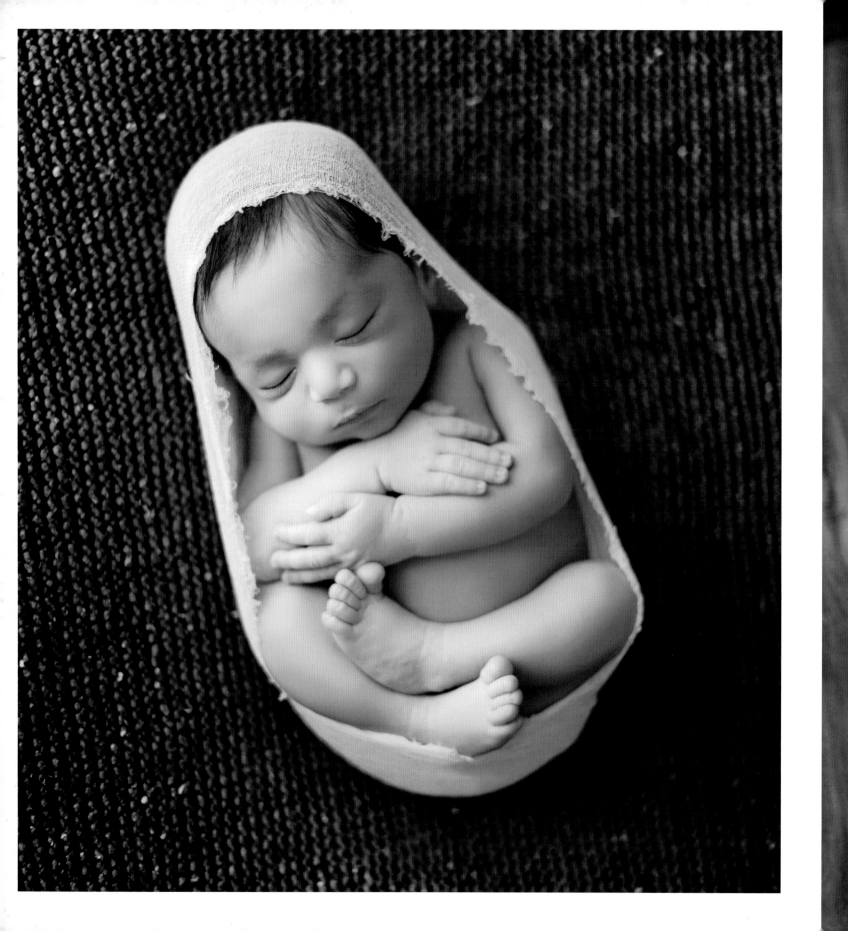

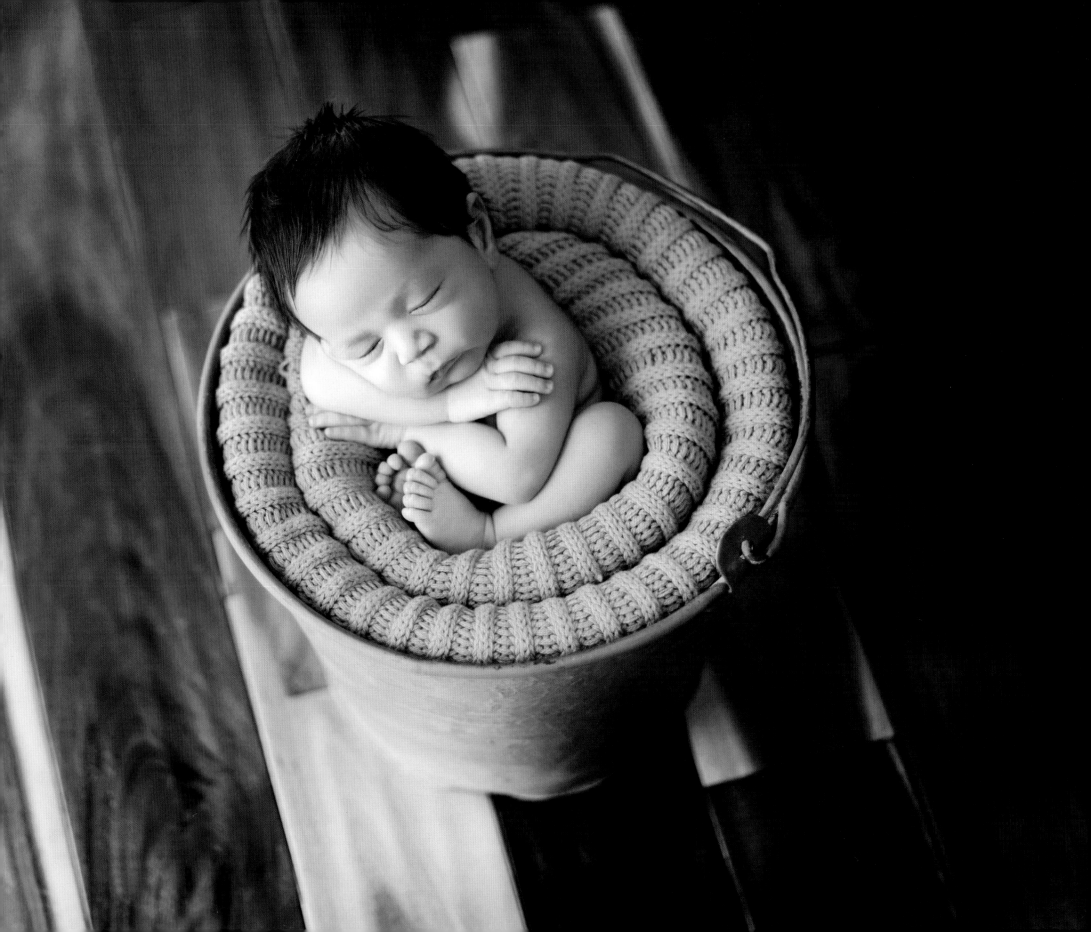

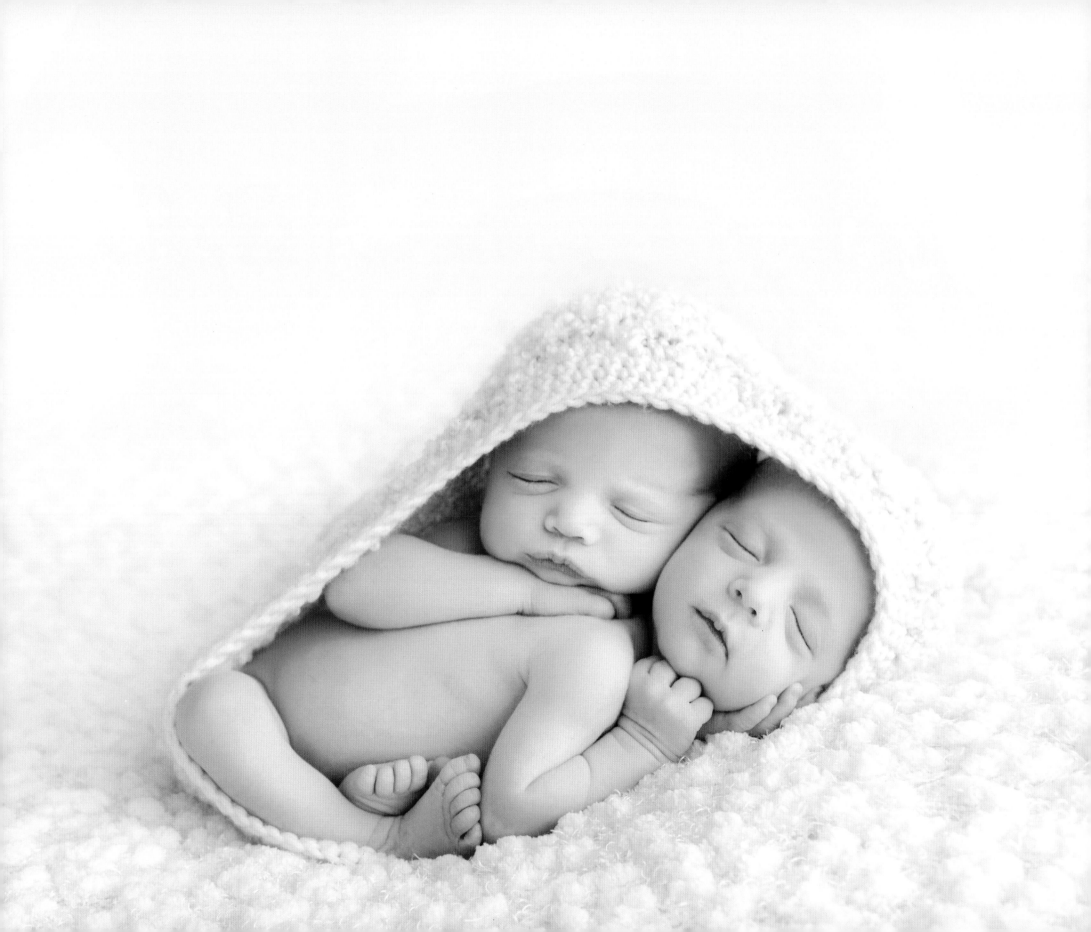

The child must know that he is a miracle, that since the beginning of the world there hasn't been, and until the end of the world there will not be, another child like him.

— *Pablo Casals*

When you have children yourself, you begin to understand what you owe your parents.

— Japanese Proverb

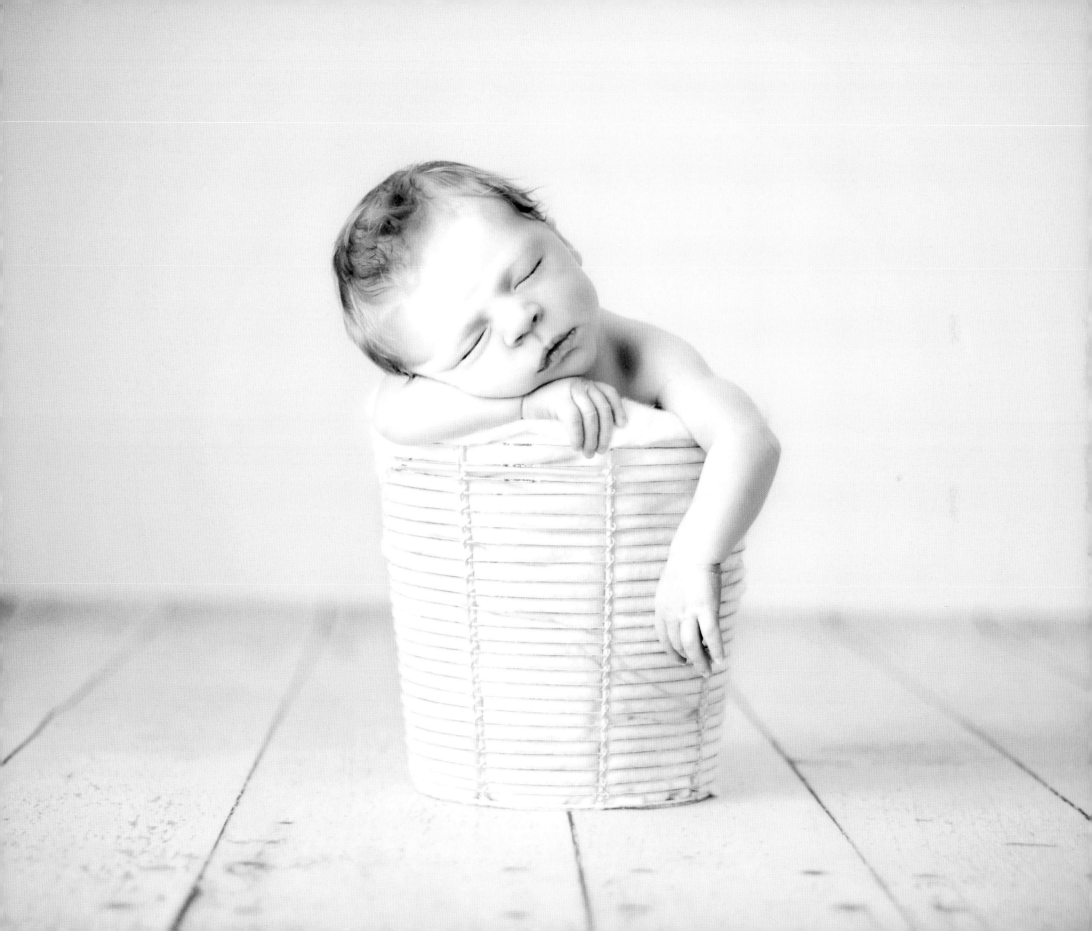

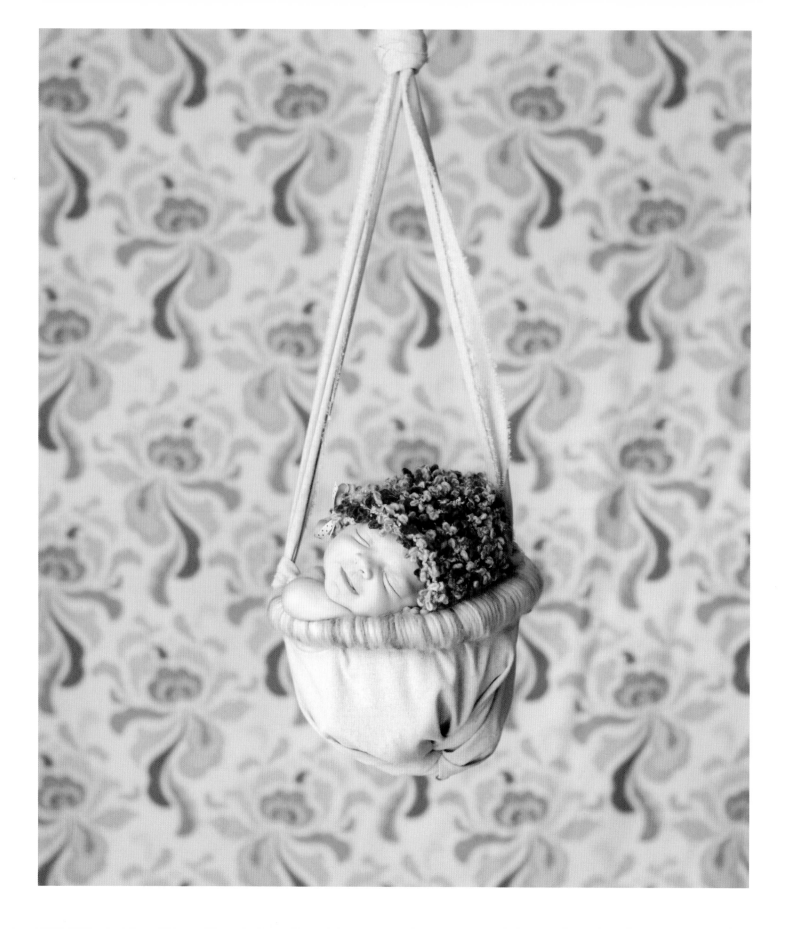

There are only two lasting bequests we can hope to give our children. One is roots; the other, wings.

— *Hodding Carter*

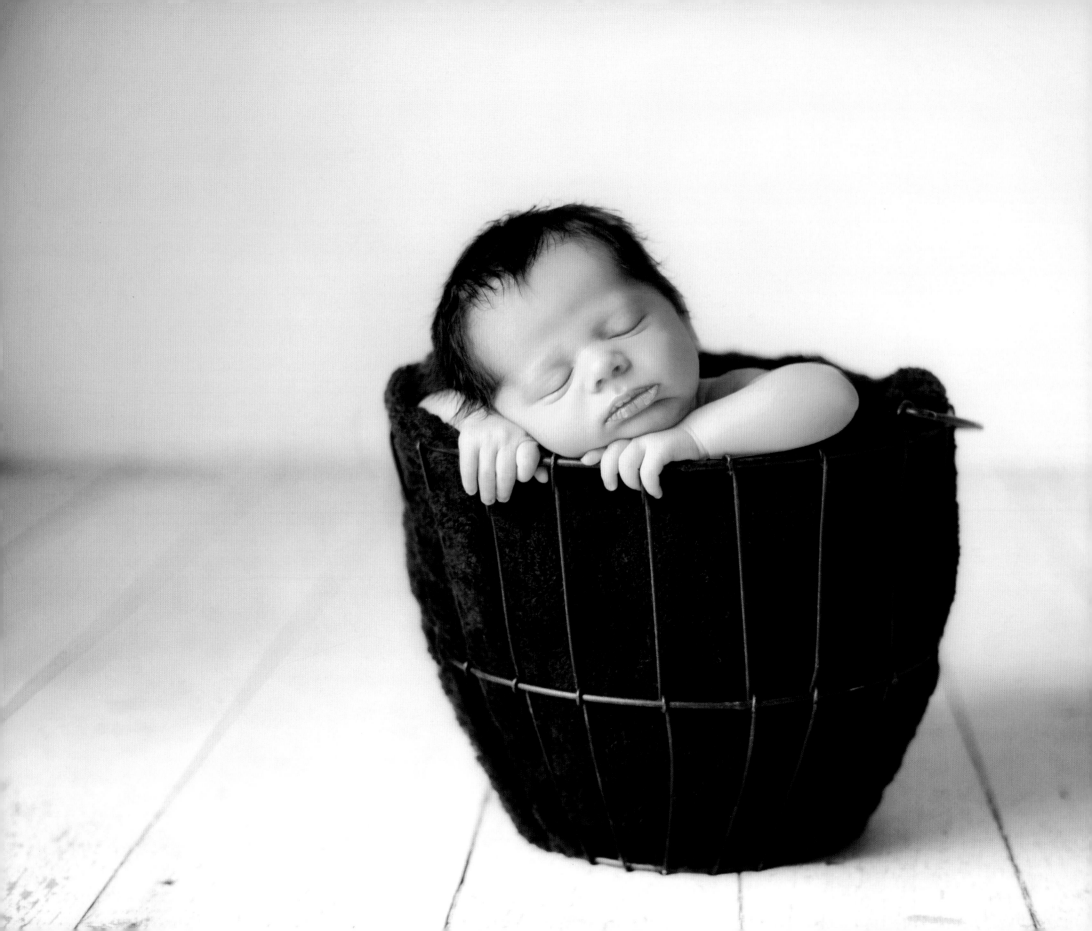

The best inheritance a parent can give to his children is a few minutes of their time each day.

— M. Grundler

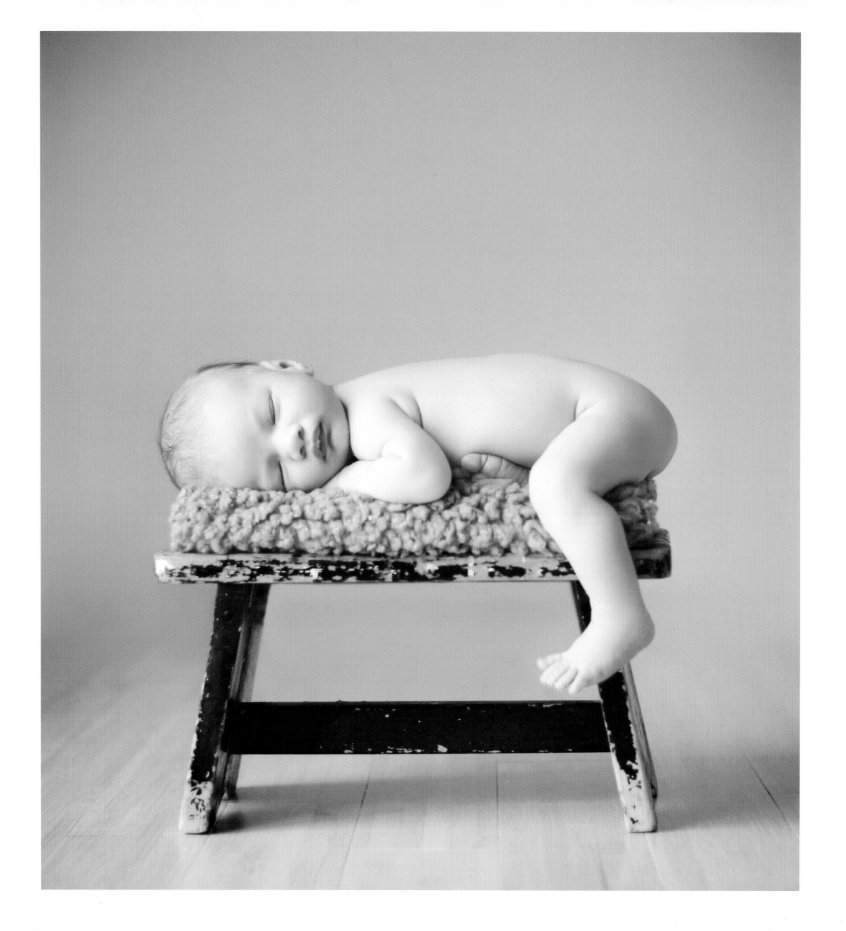

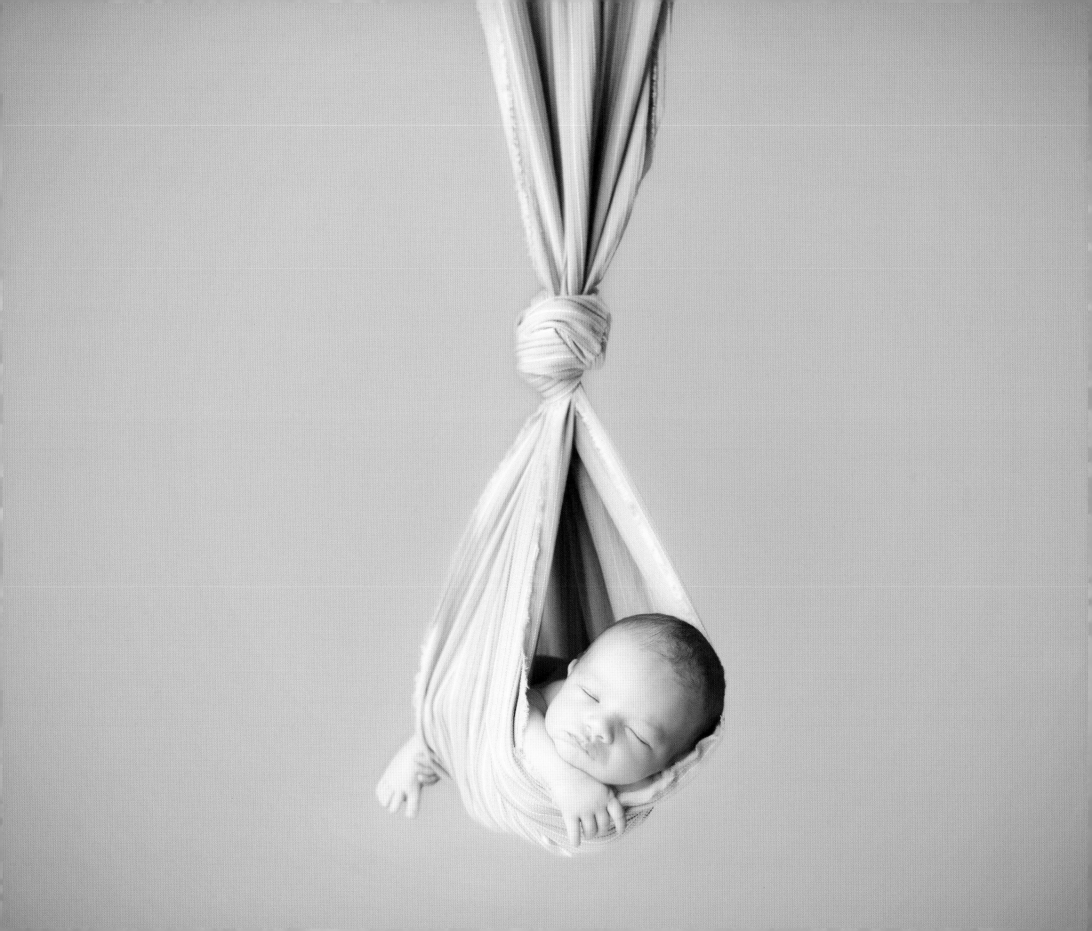

If you can give your son or daughter only one gift, let it be enthusiasm.

— *Bruce Barton*

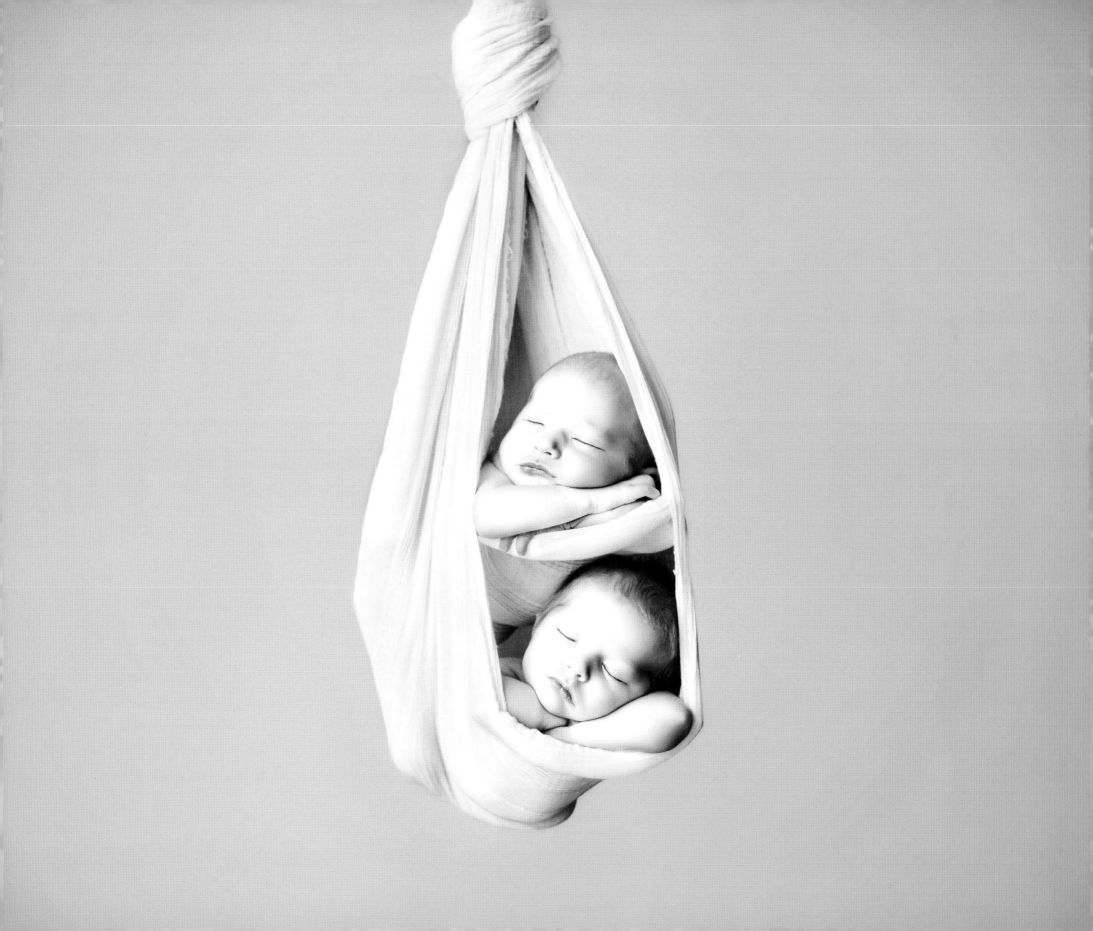

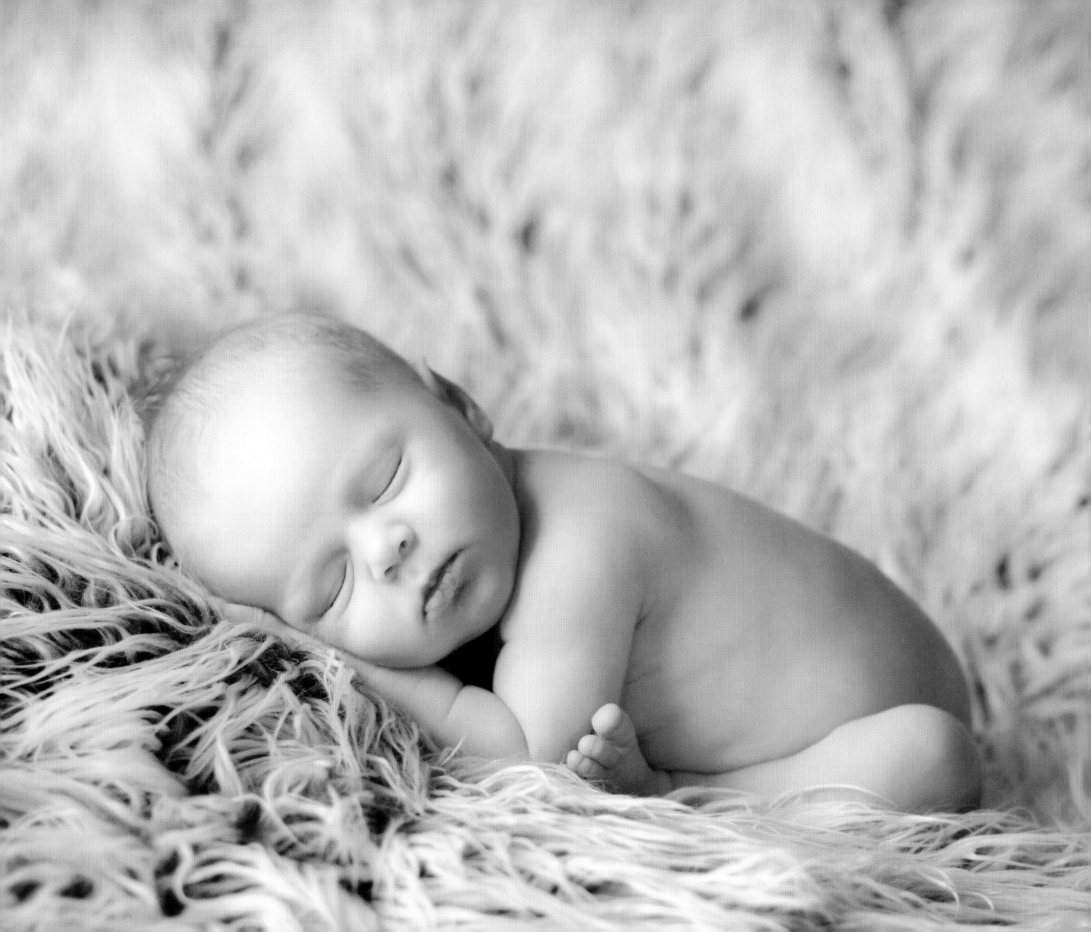

Within your heart, keep one still,
secret spot where dreams may go.

— *Louise Driscoll*

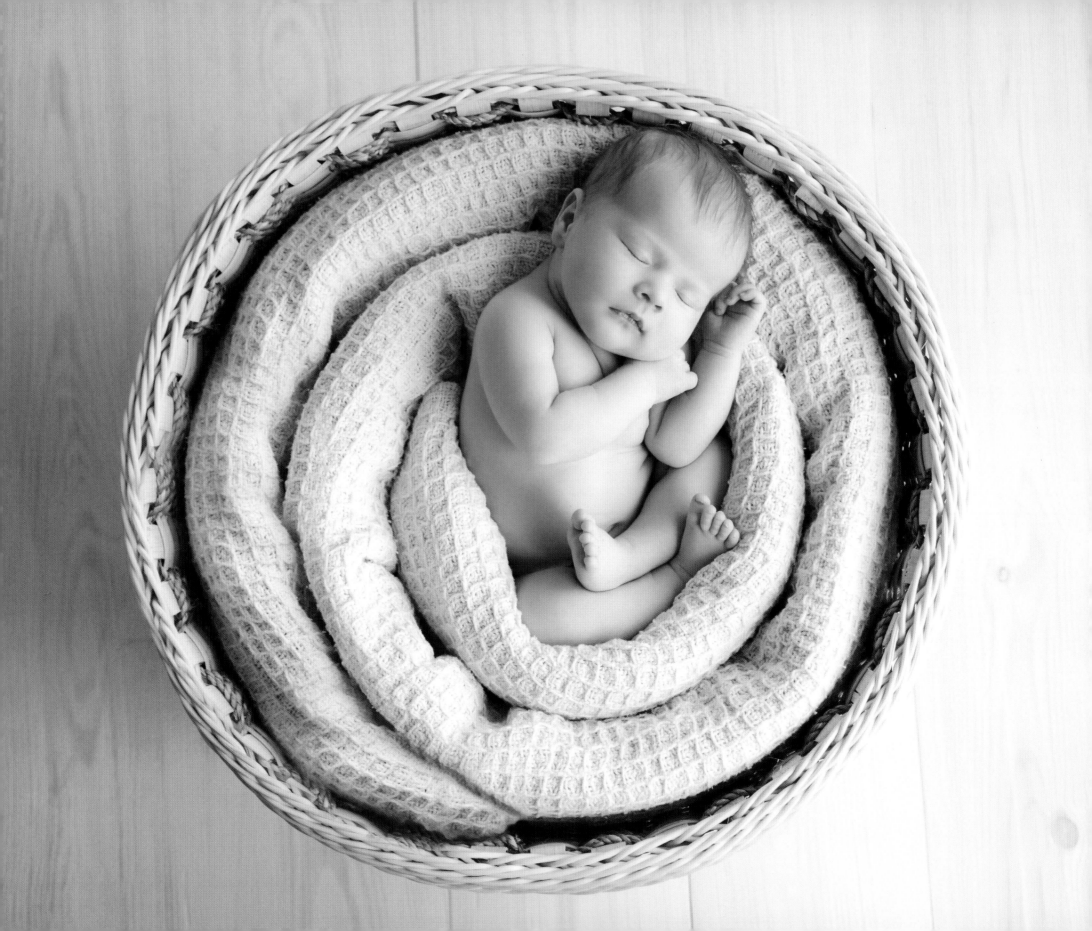

Our truest life is when we are in dreams awake.

— *Henry David Thoreau*

If you woo the company of the angels in your waking hours, they will be sure to come to you in your sleep.

— *George Dennison Prentice*

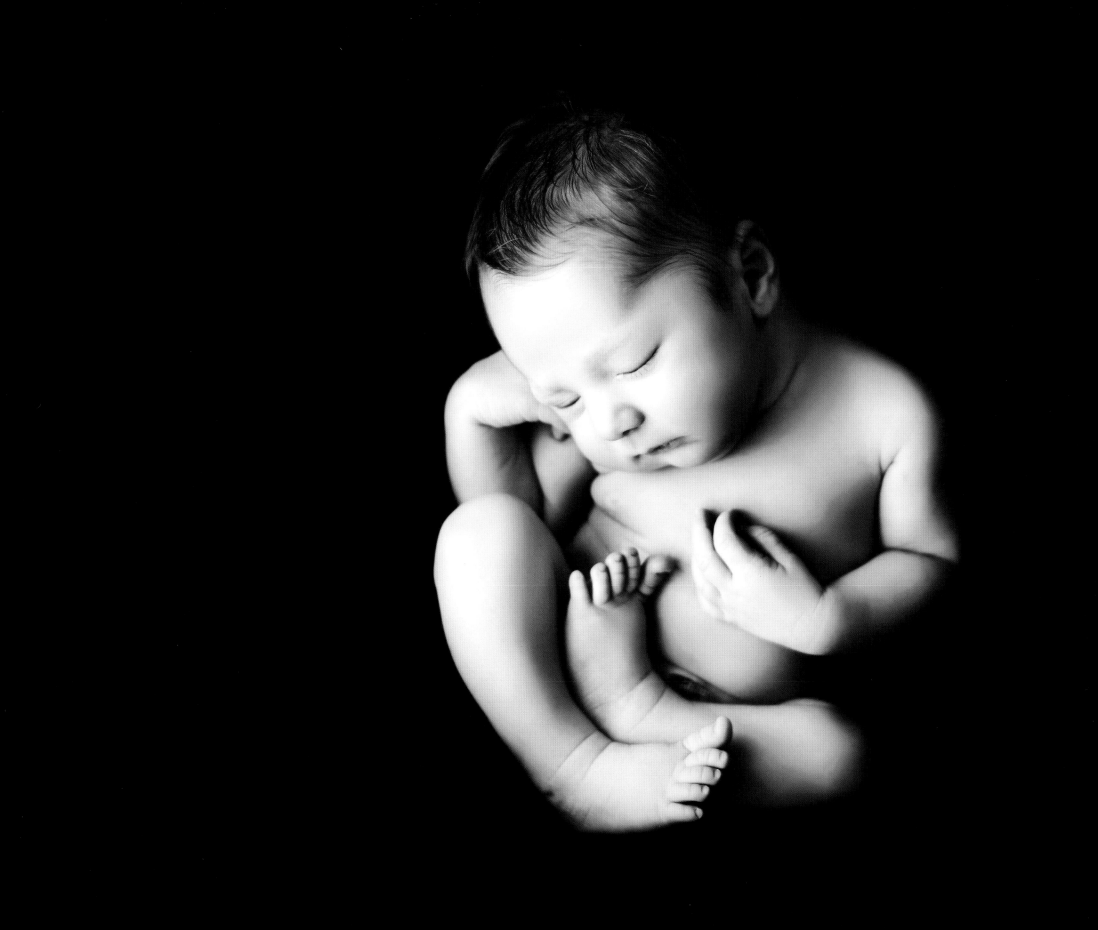

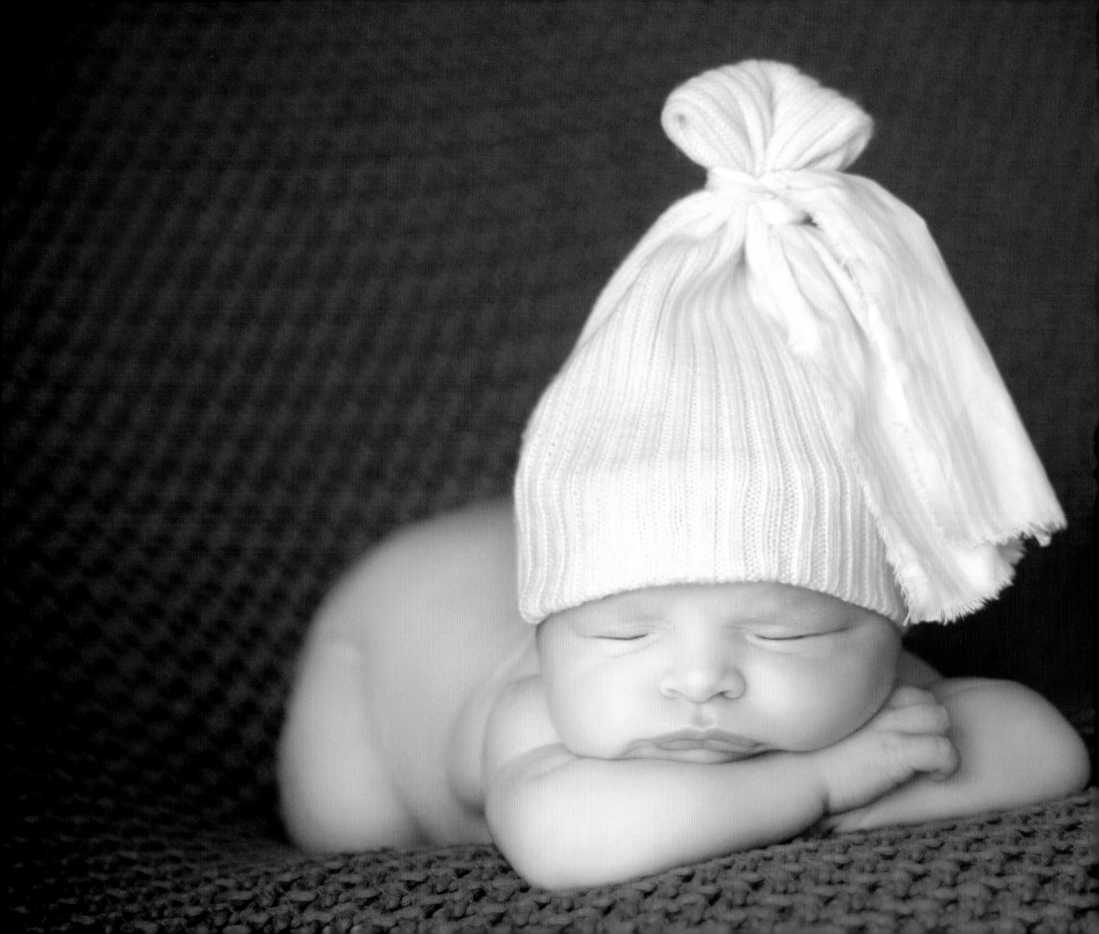

Each day comes bearing its own gifts.
Untie the ribbons.

— Ruth Ann Schabacker

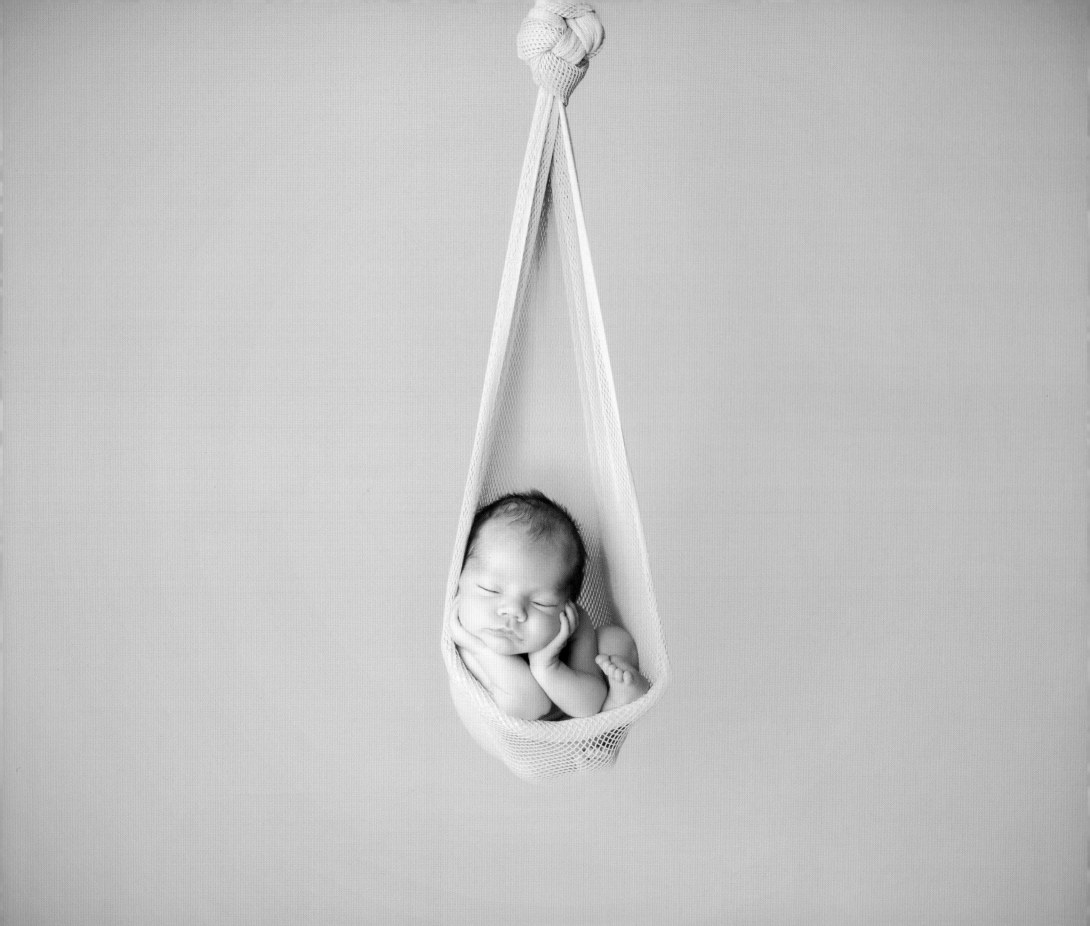

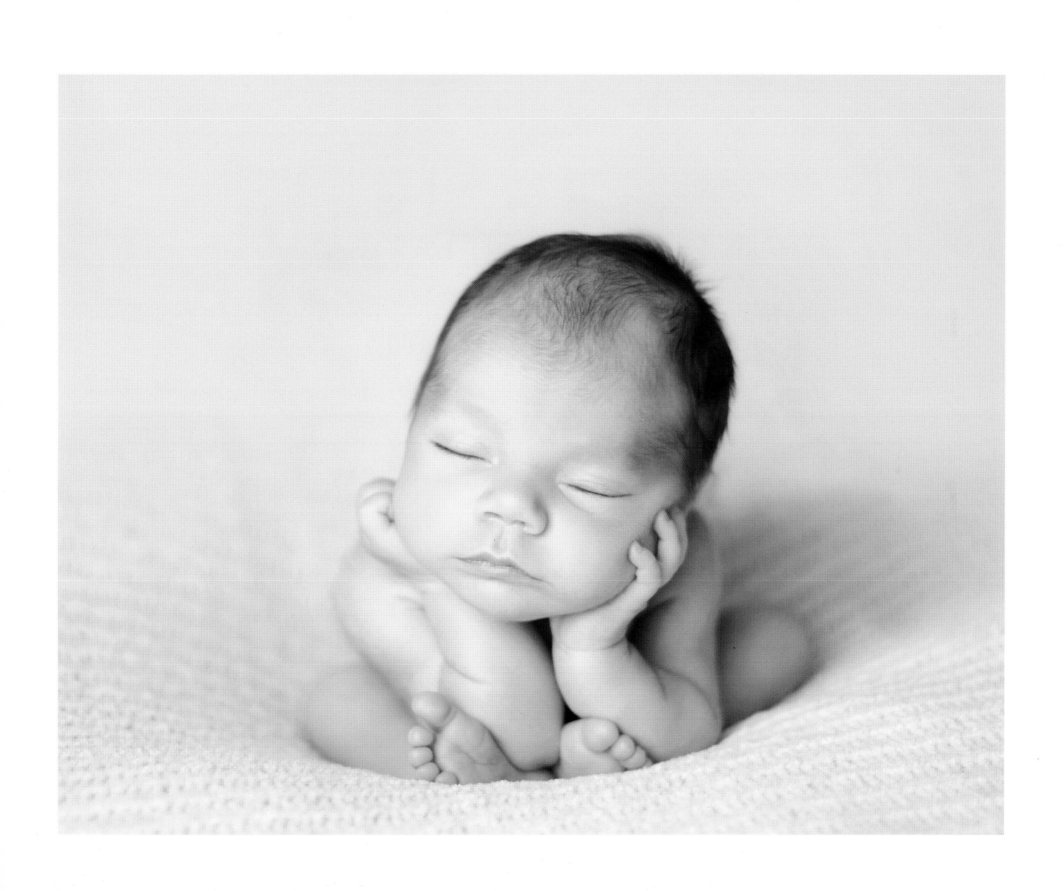

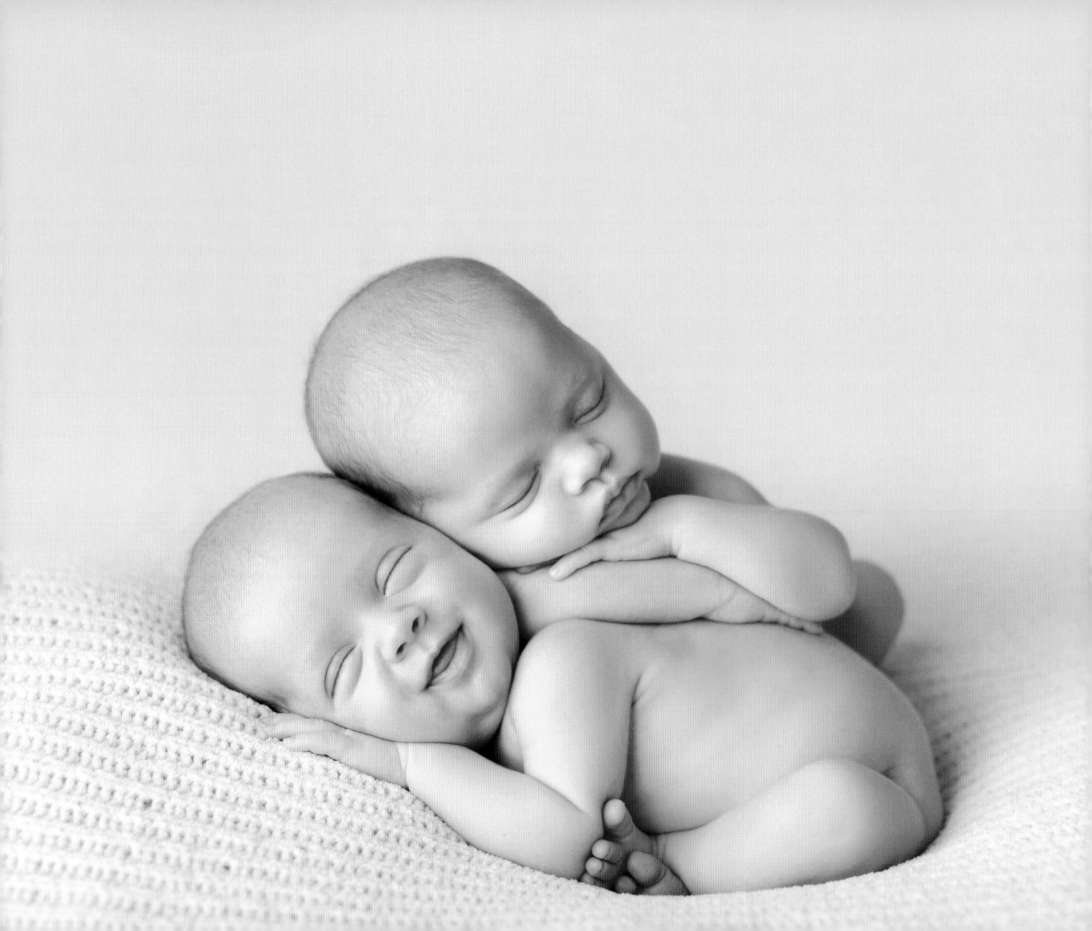

Where there is love there is no question.

— *Albert Einstein*

Where did you come from, baby dear?
Out of the Everywhere into here.

<div align="right">

— *George MacDonald*

</div>

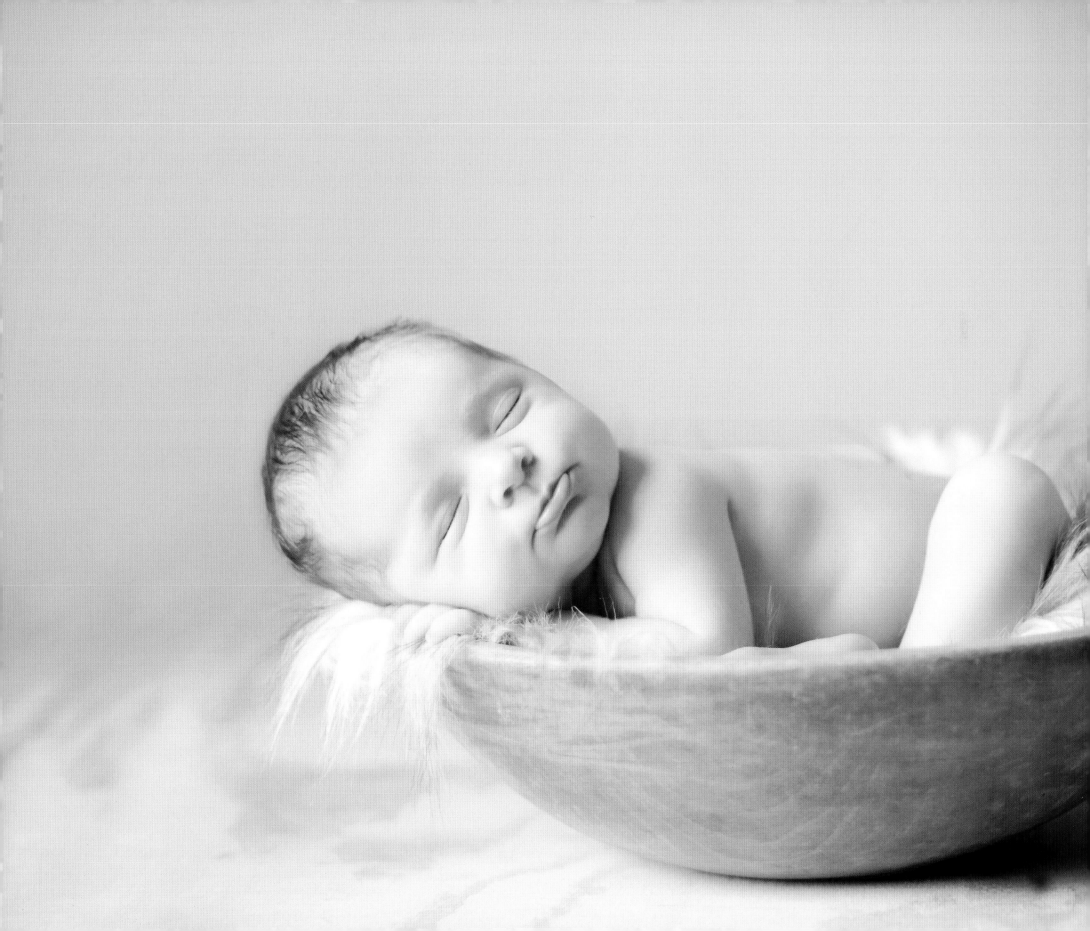

Each day of our lives we make deposits in the memory banks of our children.

— Charles R. Swindoll

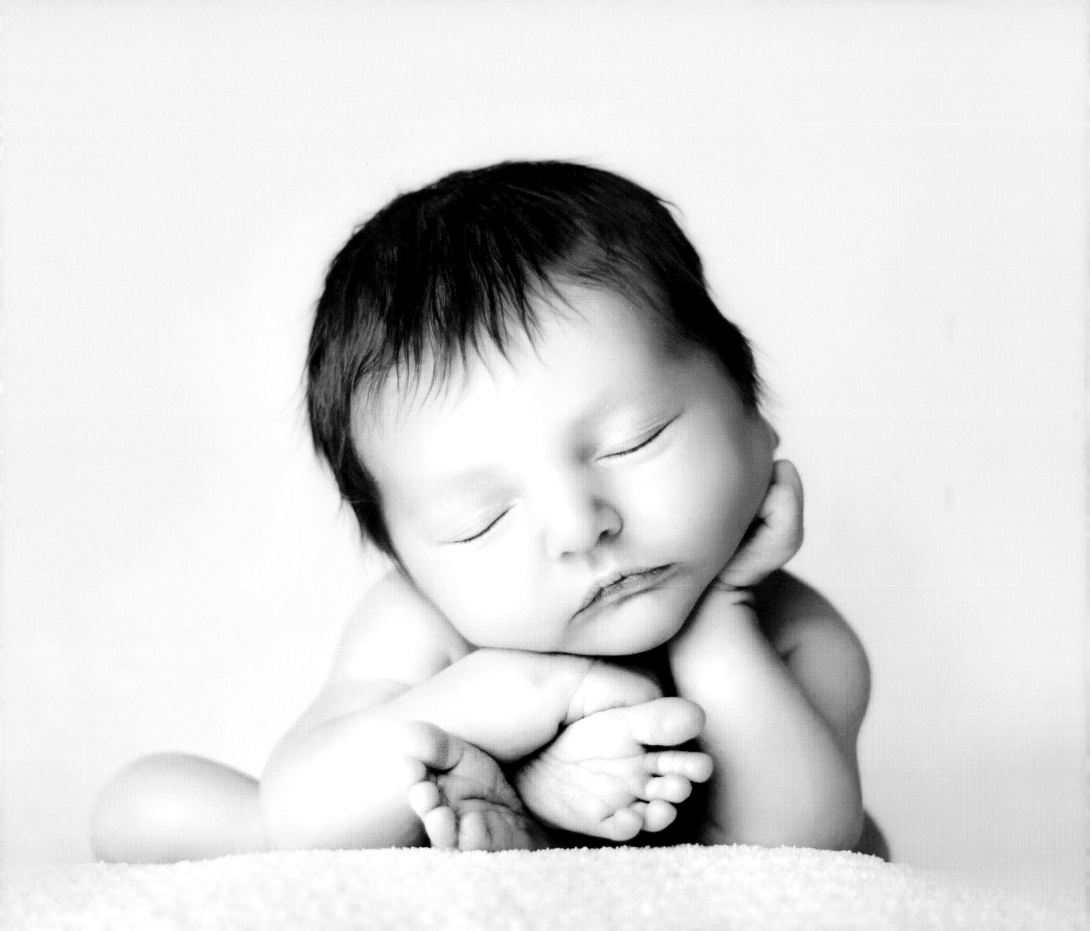

Always kiss your children goodnight,
even if they're already asleep.

— *H. Jackson Brown, Jr.*

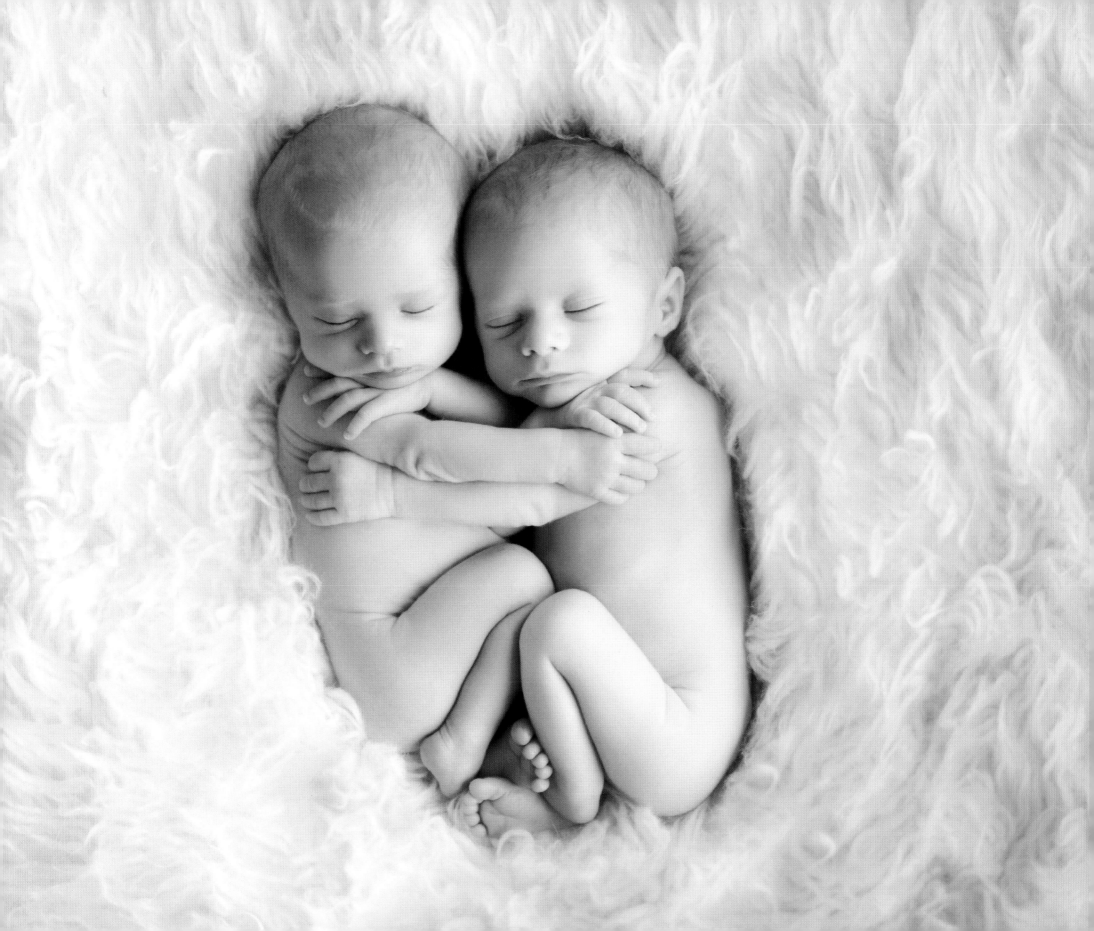

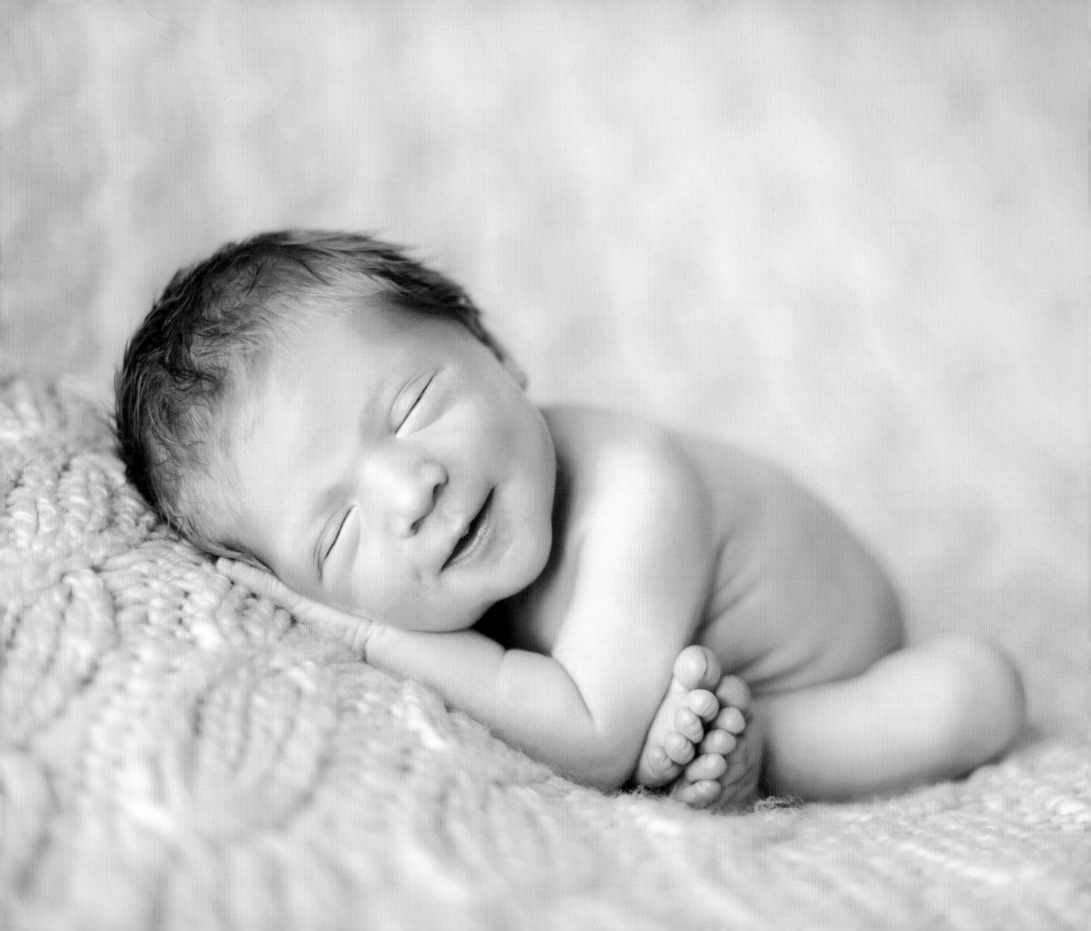

A pillow for thee will I bring,
Stuffed with down of angel's wing.

<div align="right">

— *Richard Crashaw*

</div>

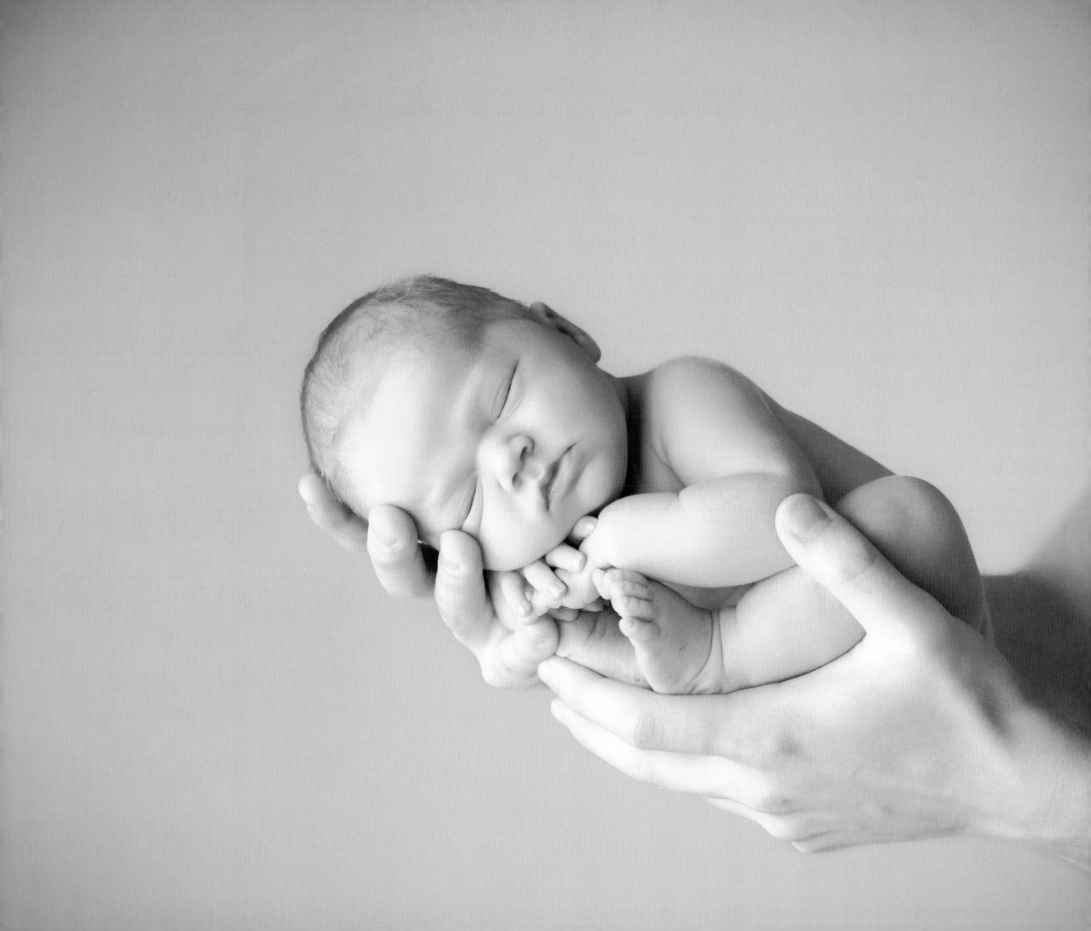

Let us put our minds together and see what life we can make for our children.

— *Tatanka Iyotanka*

Children are the hands by which we take hold of heaven.

— Henry Ward Beecher

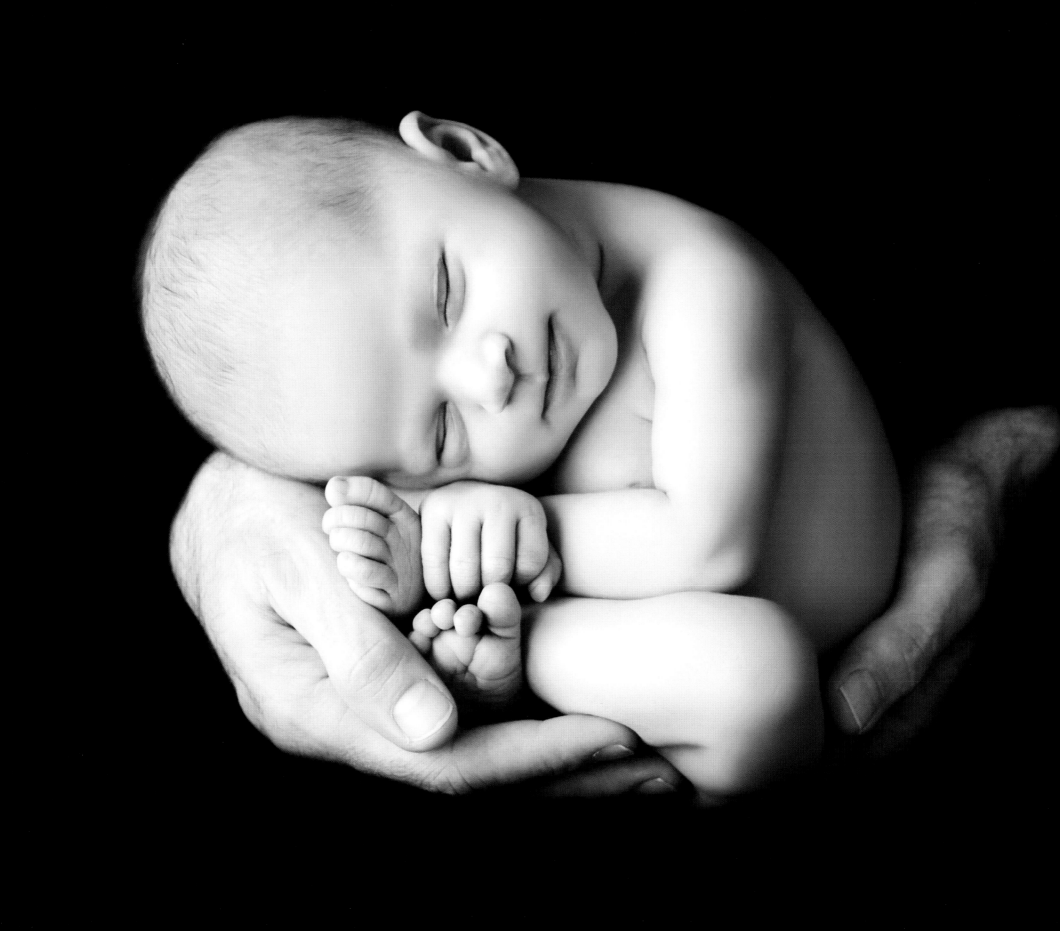

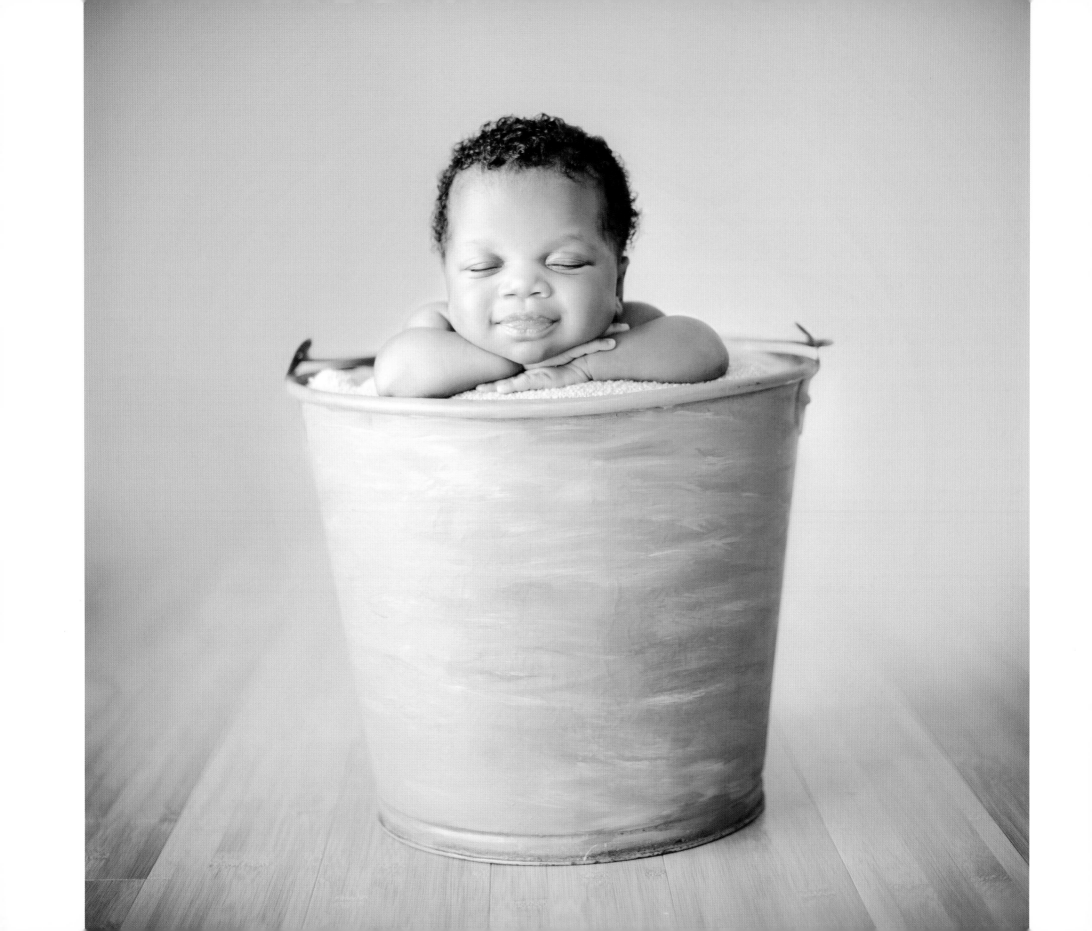

Love is indeed heaven upon earth; since heaven above would not be heaven without it.

— *William Penn*

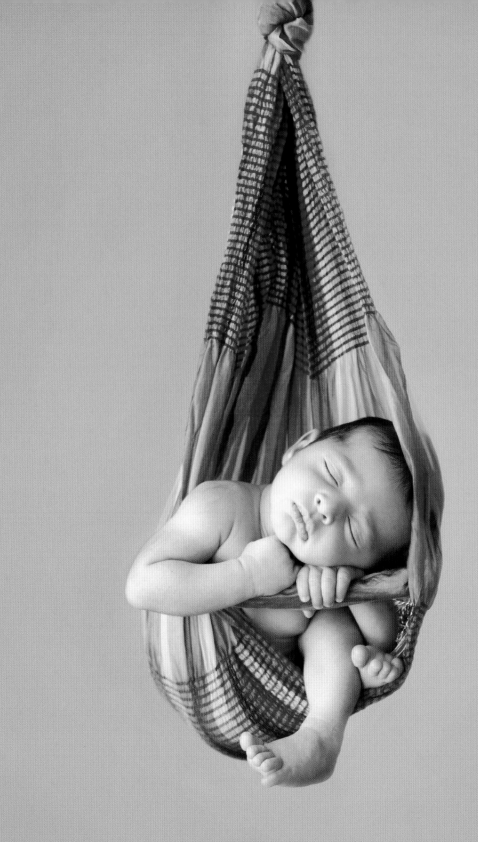

'Tis love that makes the world go 'round, my baby.

— *Charles Dickens*

We are the leaves of one branch, the drops of one sea, the flowers of one garden.

— *Jean Baptiste Henri Lacordaire*

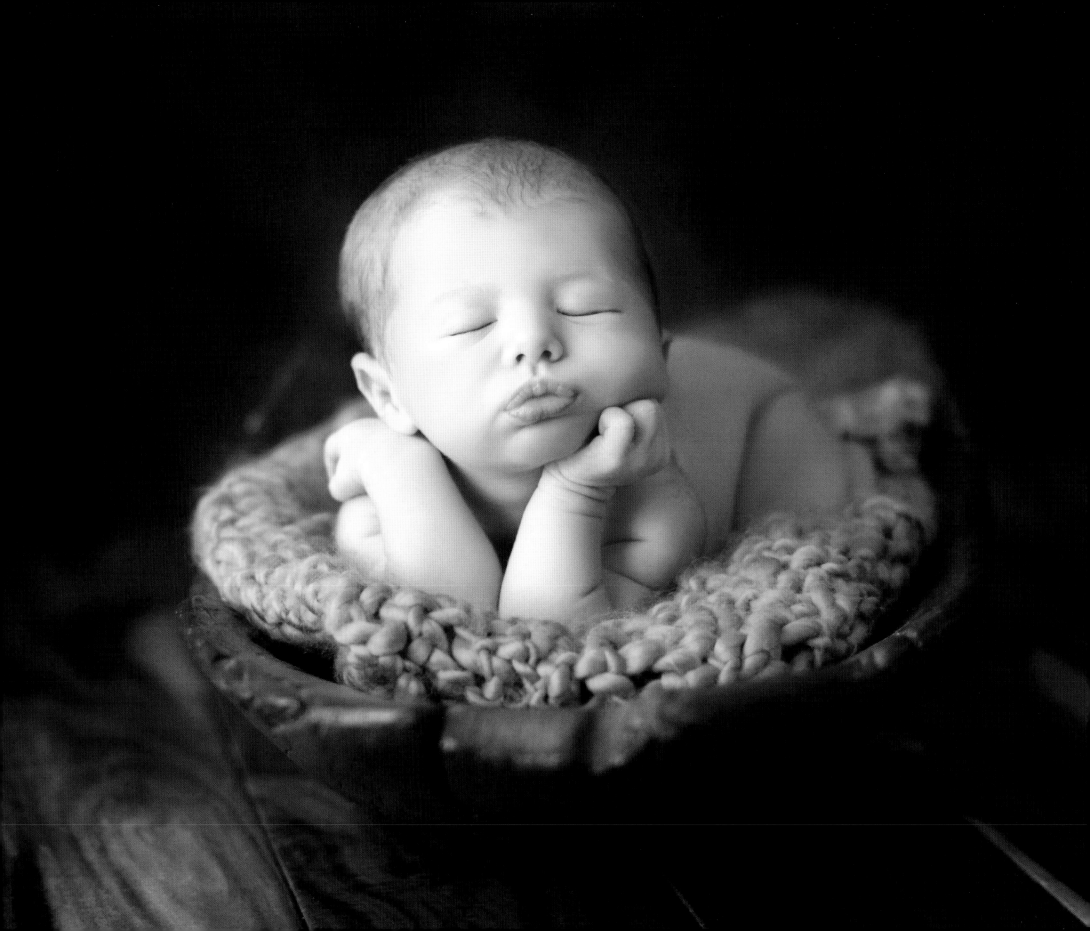

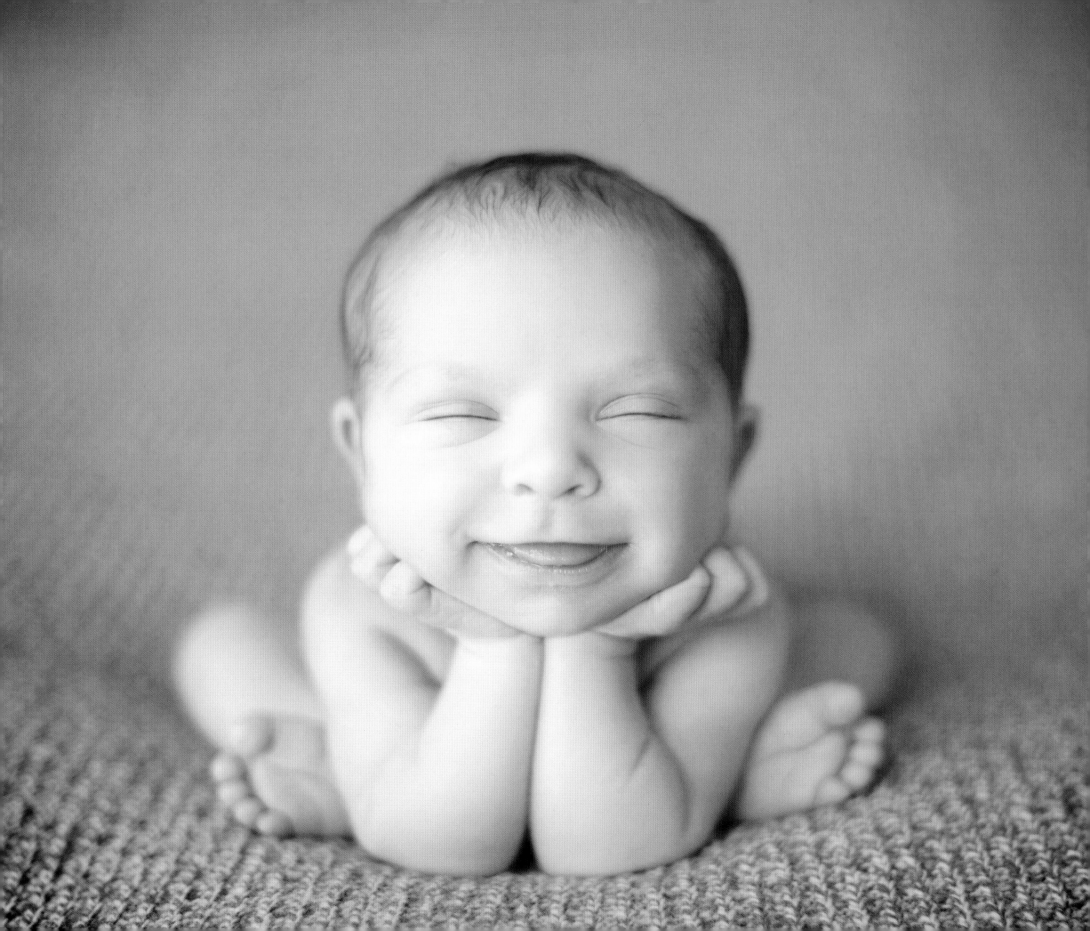

When the first baby laughed for the first time, the laugh broke into a thousand pieces and they all went skipping about, and that was the beginning of fairies.

— James M. Barrie

In dreams and in love there are no impossibilities.

— János Arany

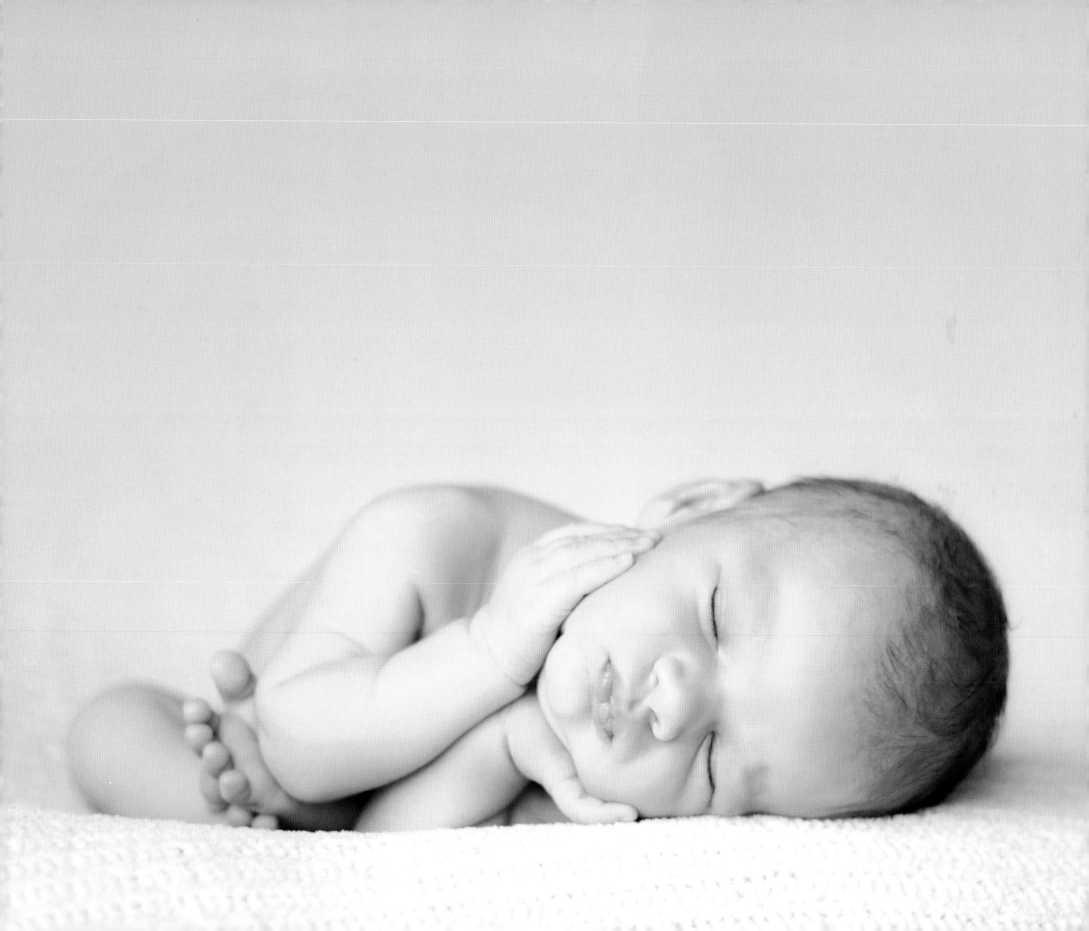

The smile that flickers on baby's lips when he sleeps — does anybody know where it was borne?

— Rabindranath Tagore

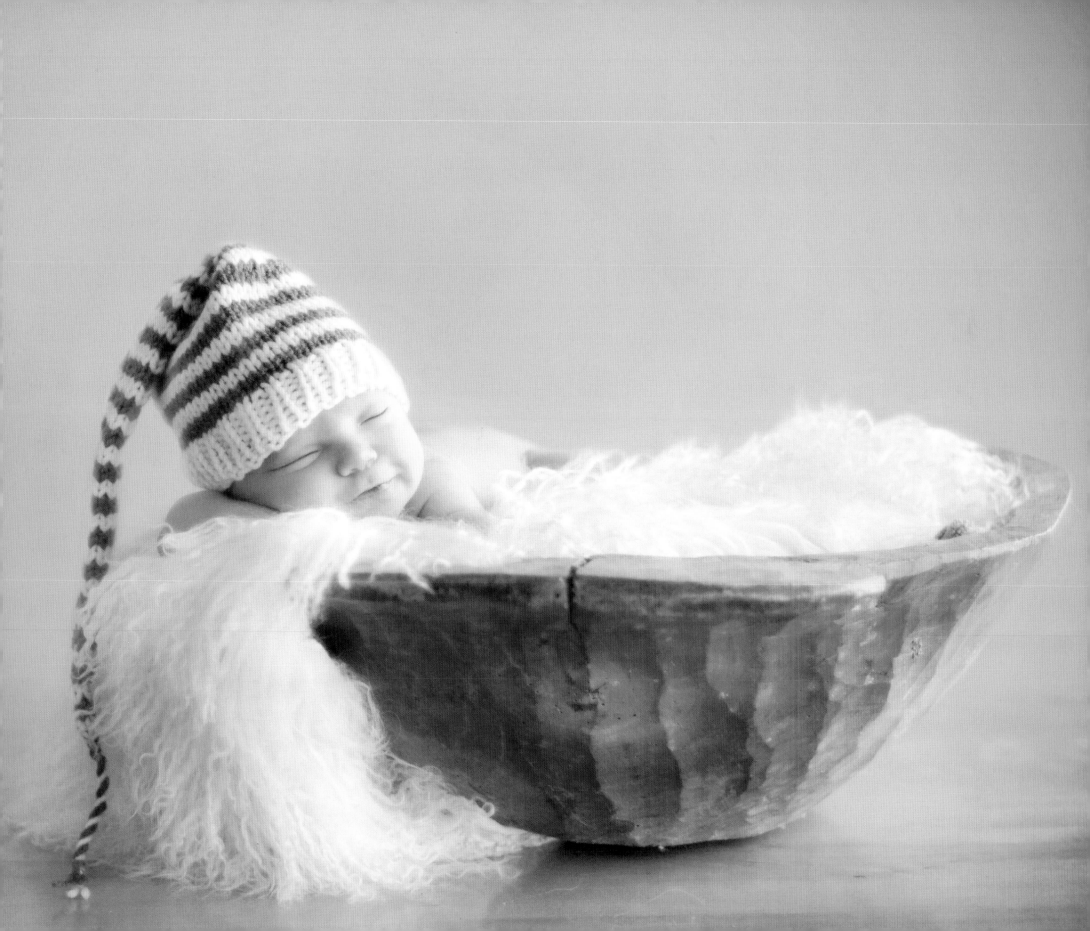

We all smile in the same language.

— Anonymous

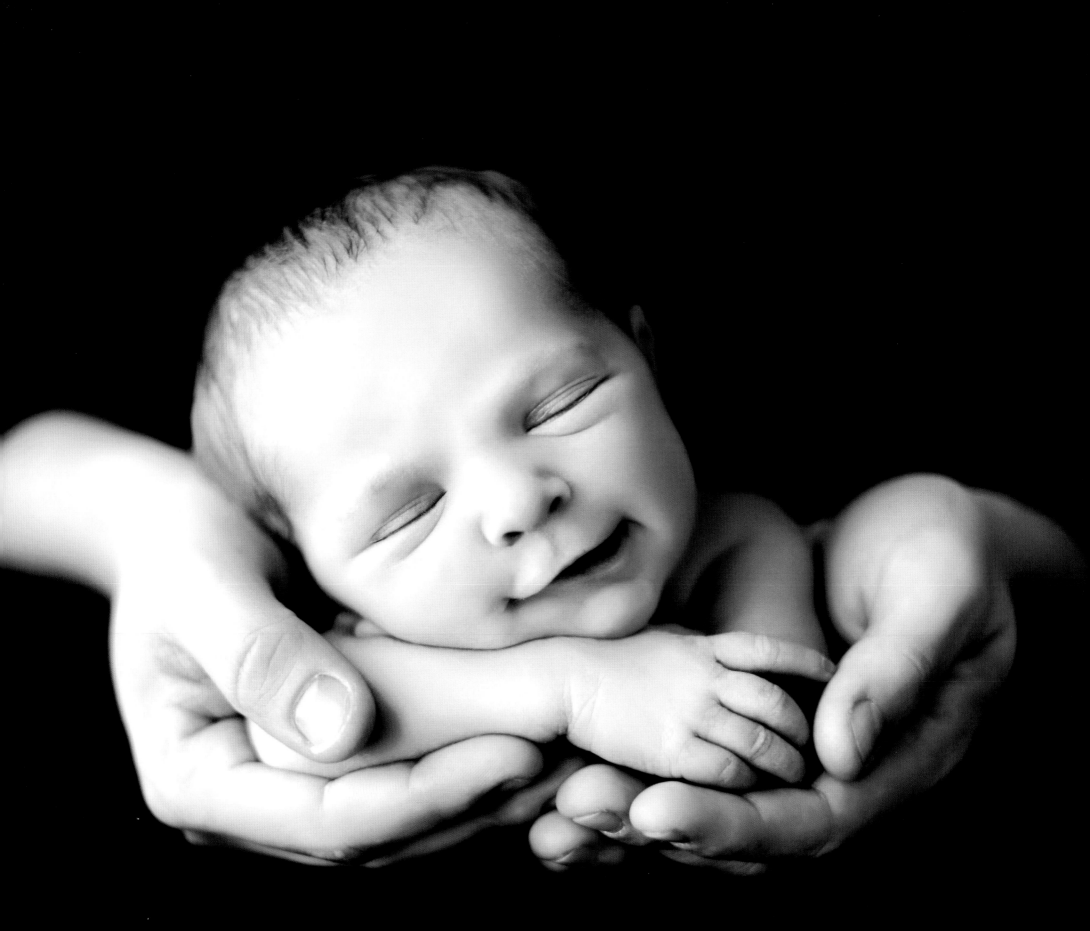

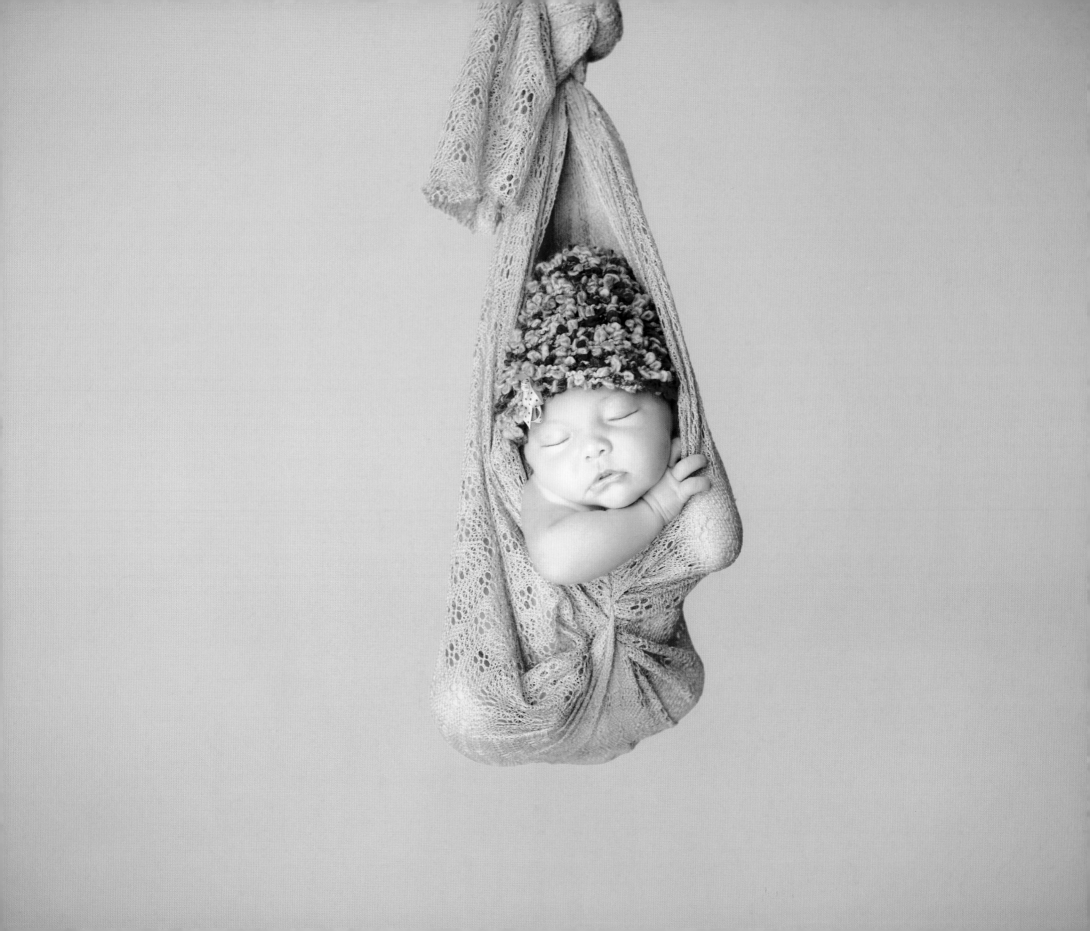

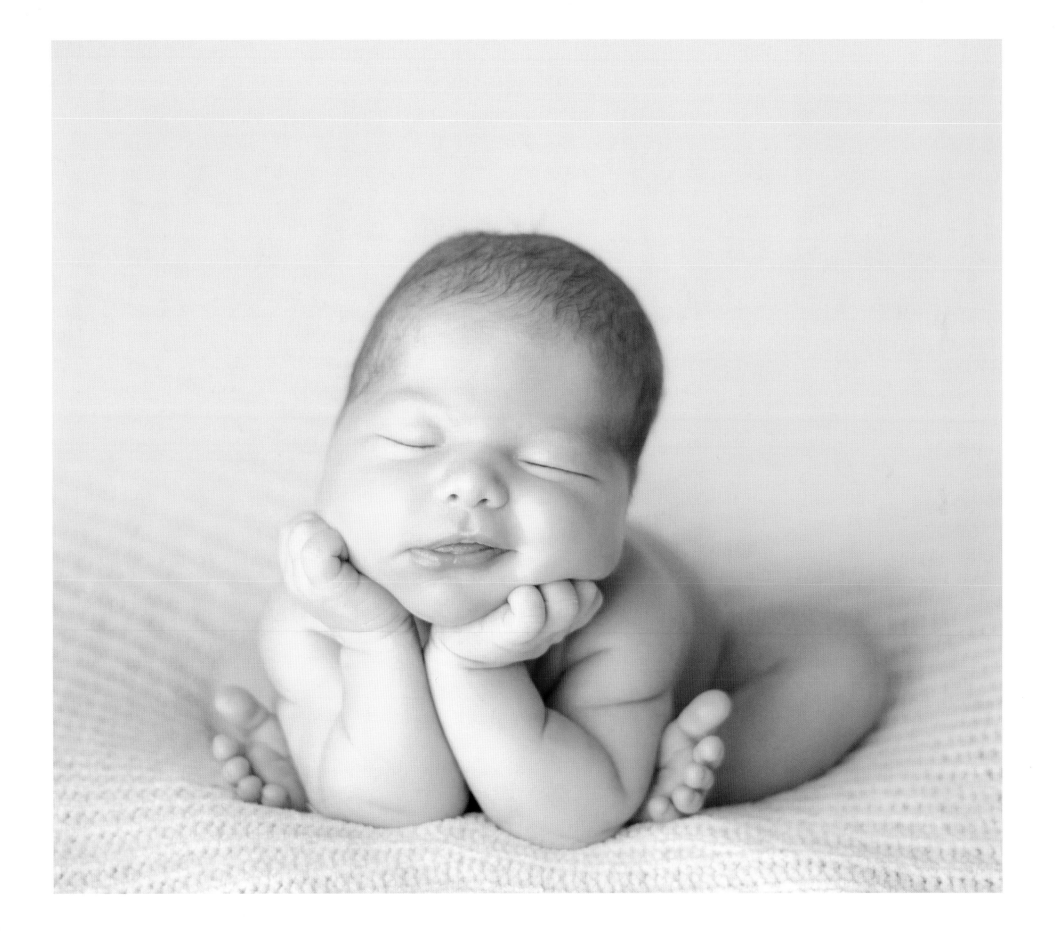

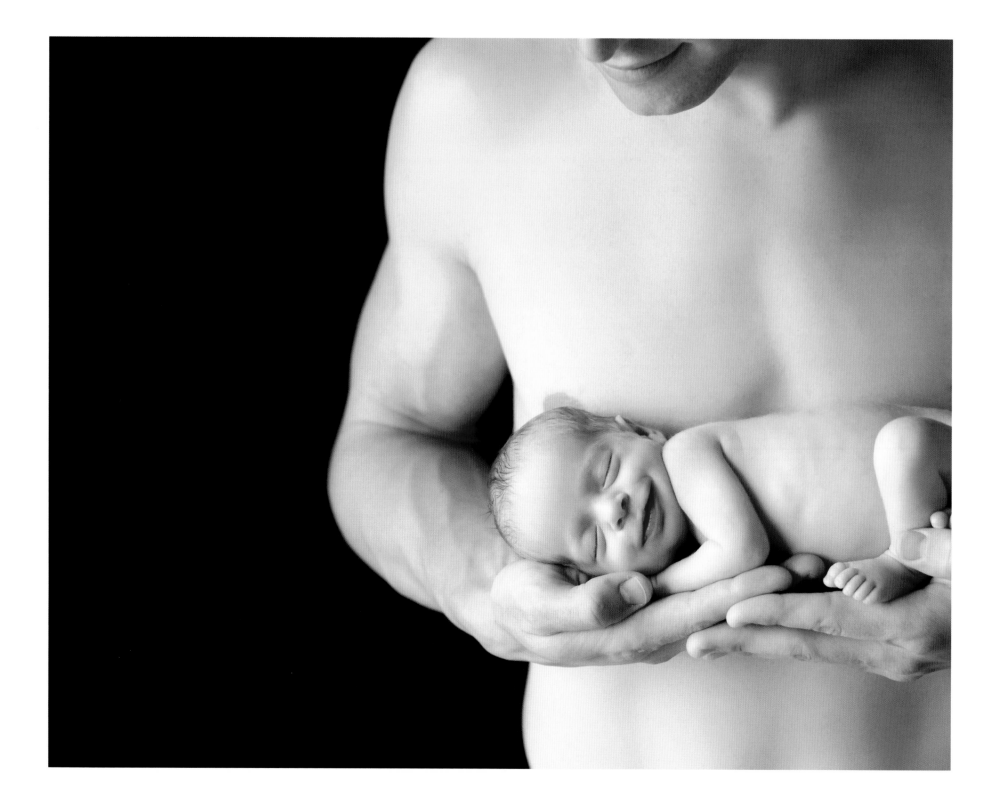

Sweet babe, in thy face
Soft desires I can trace,
Secret joys and secret smiles,
Little pretty infant wiles.

— *William Blake*

*May you always have
A sunbeam to warm you,
A moonbeam to charm you,
A sheltering angel,
So nothing can harm you.*

— *Irish Blessing*

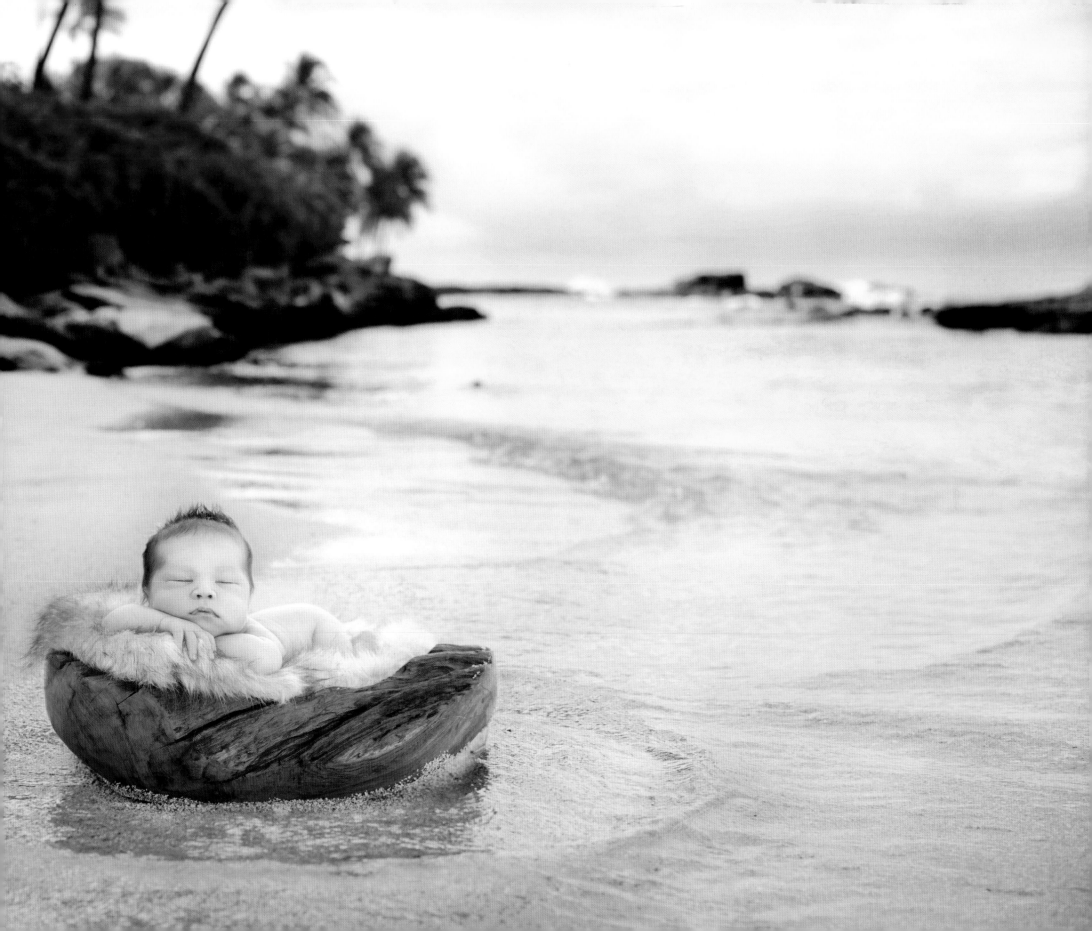

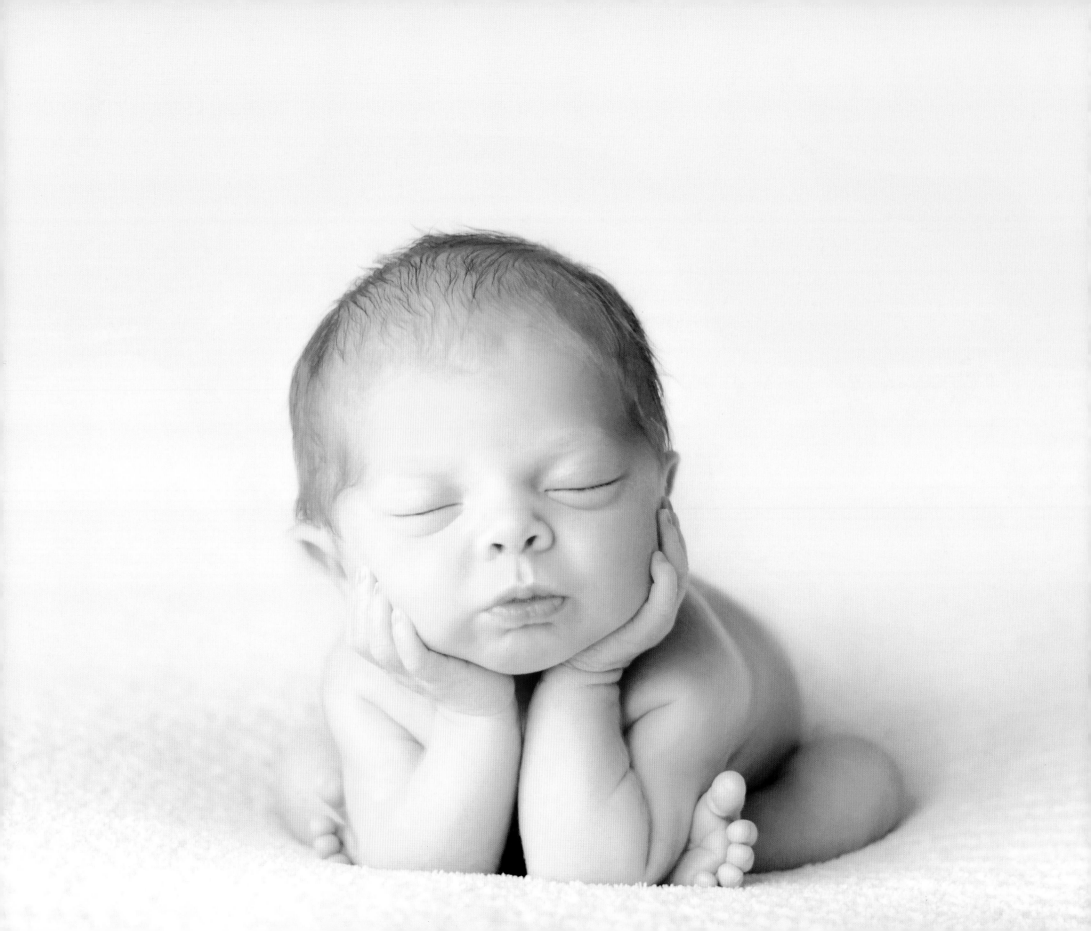

It is the nature of babies to be in bliss.

— Deepak Chopra

The greatest happiness of life is the conviction that we are loved.

— *Victor Hugo*

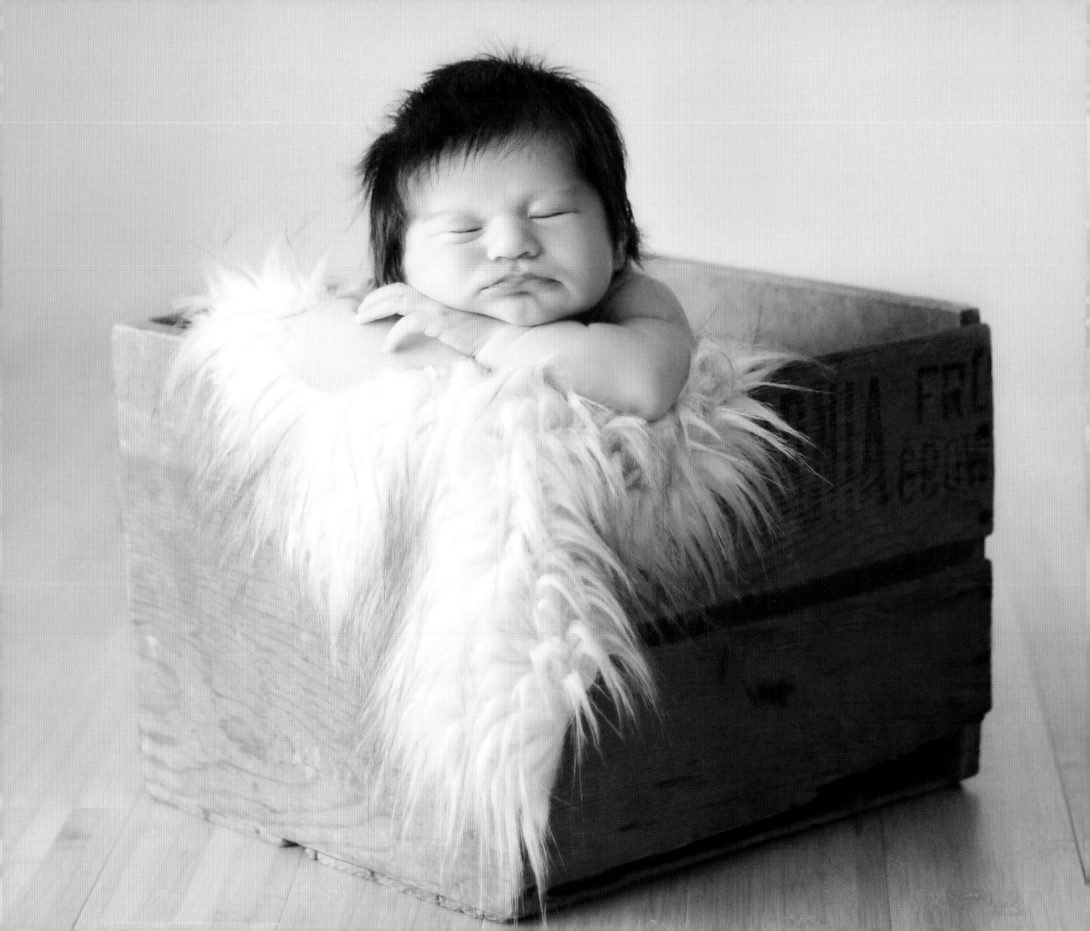

Praise is like sunlight to the human spirit:
we cannot flower and grow without it.

— Jess Lair

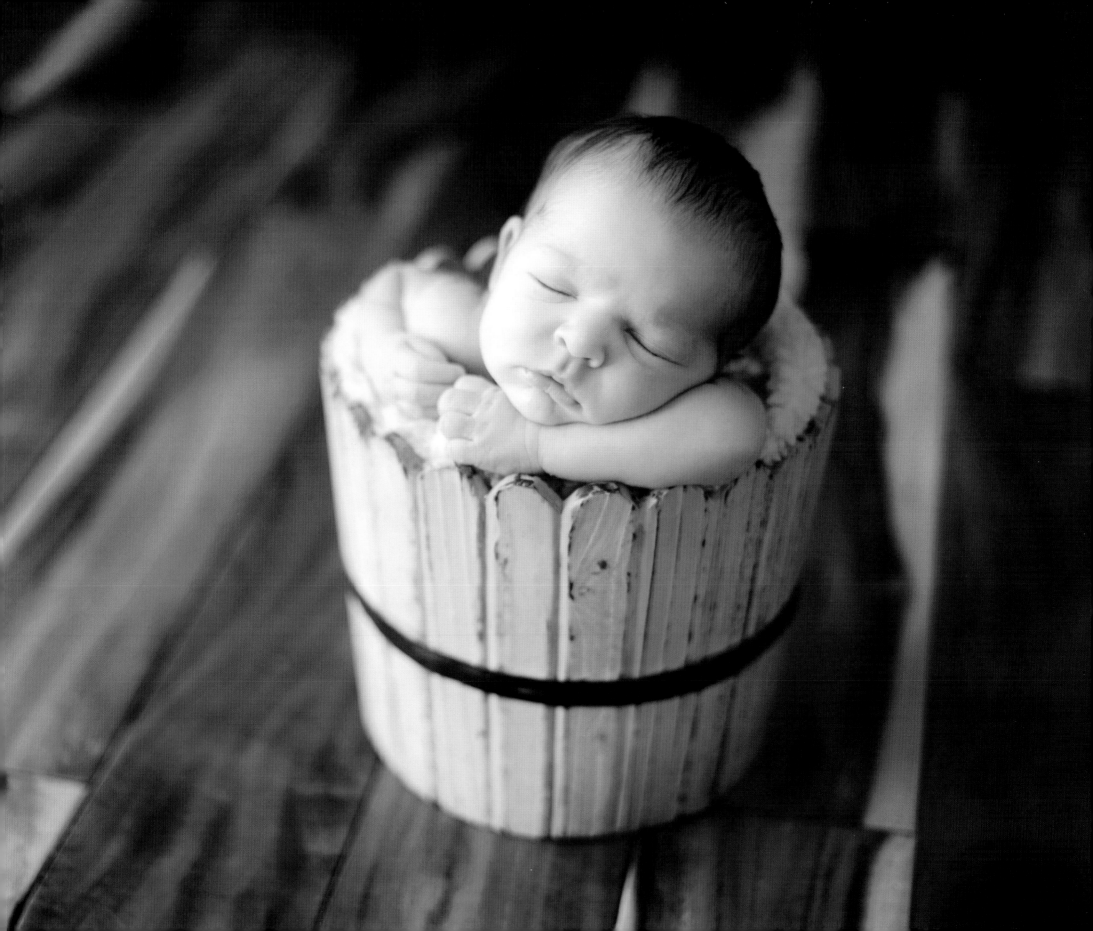

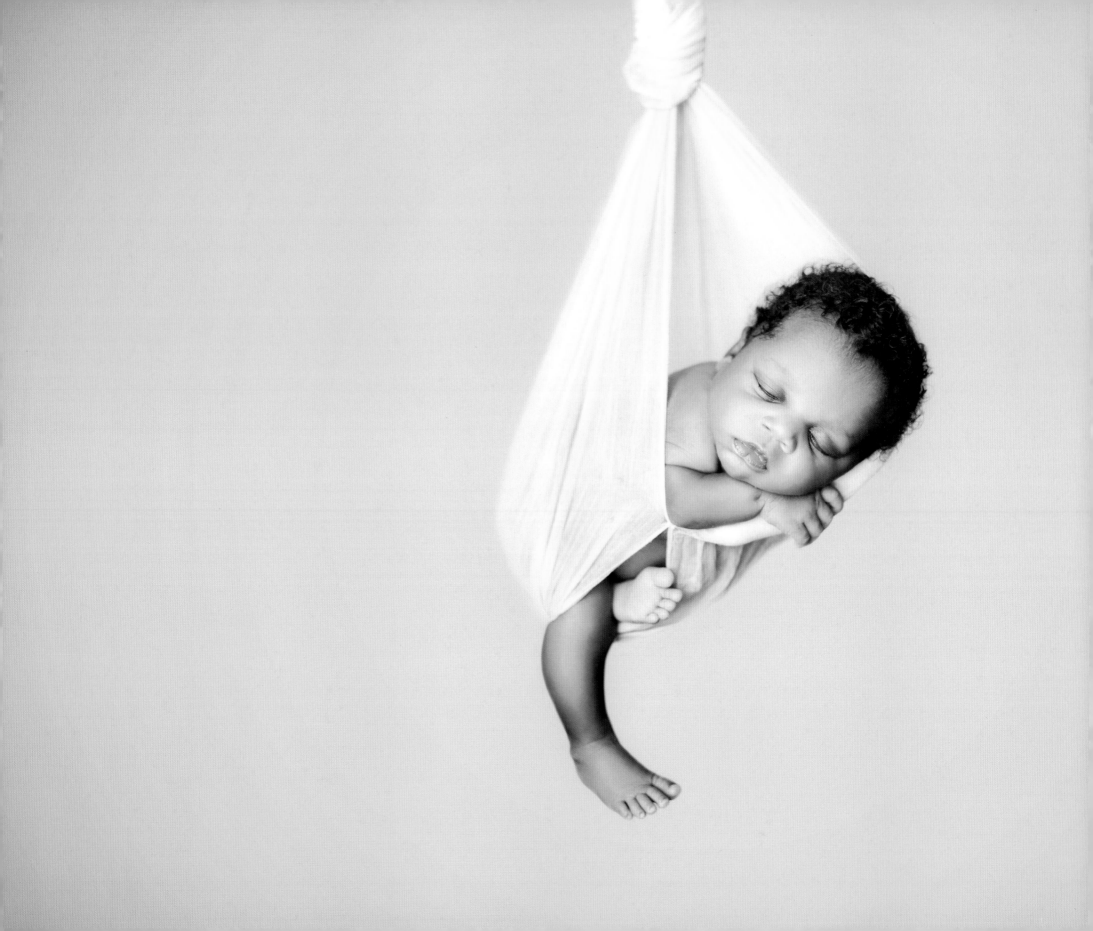

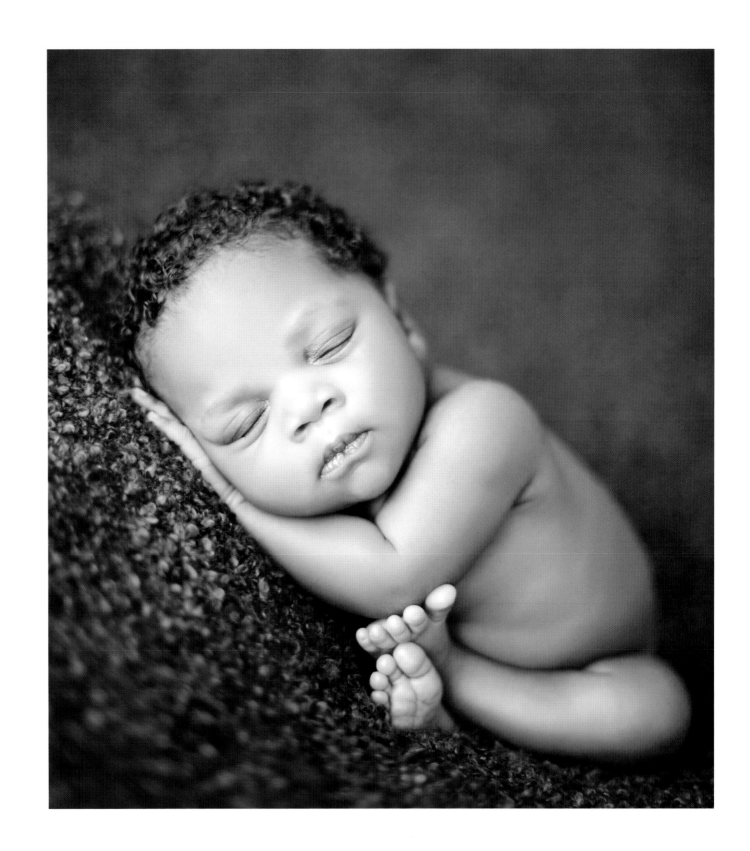

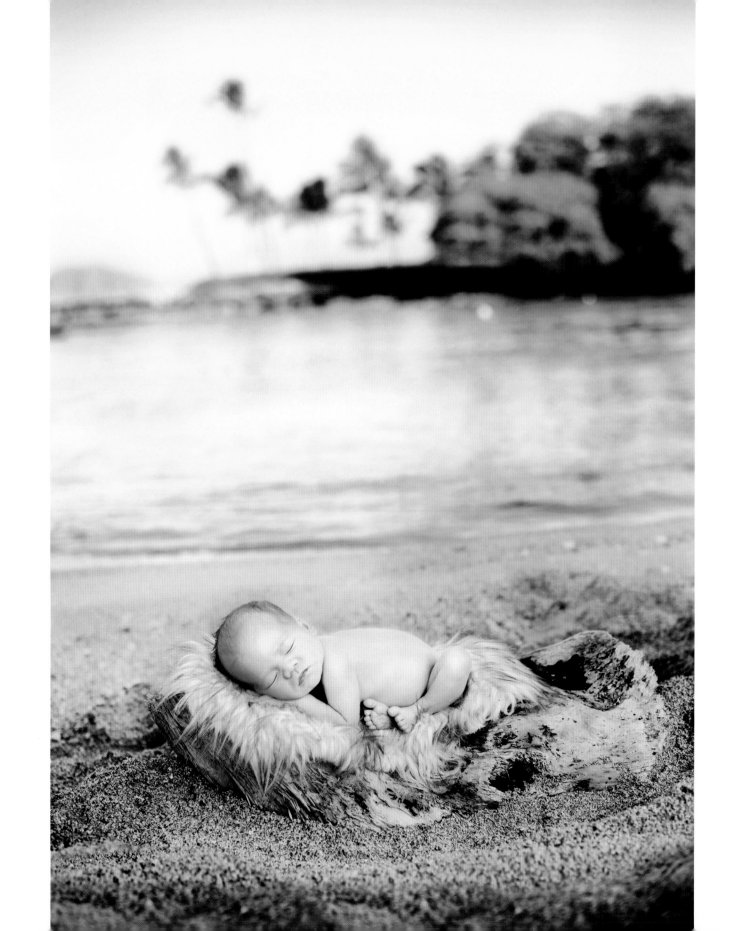

*Three grand essentials to happiness
in this life are something to do,
something to love,
and something to hope for.*

— Joseph Addison

The angels often speak to babies while they are asleep.

— *Elias Freeman*

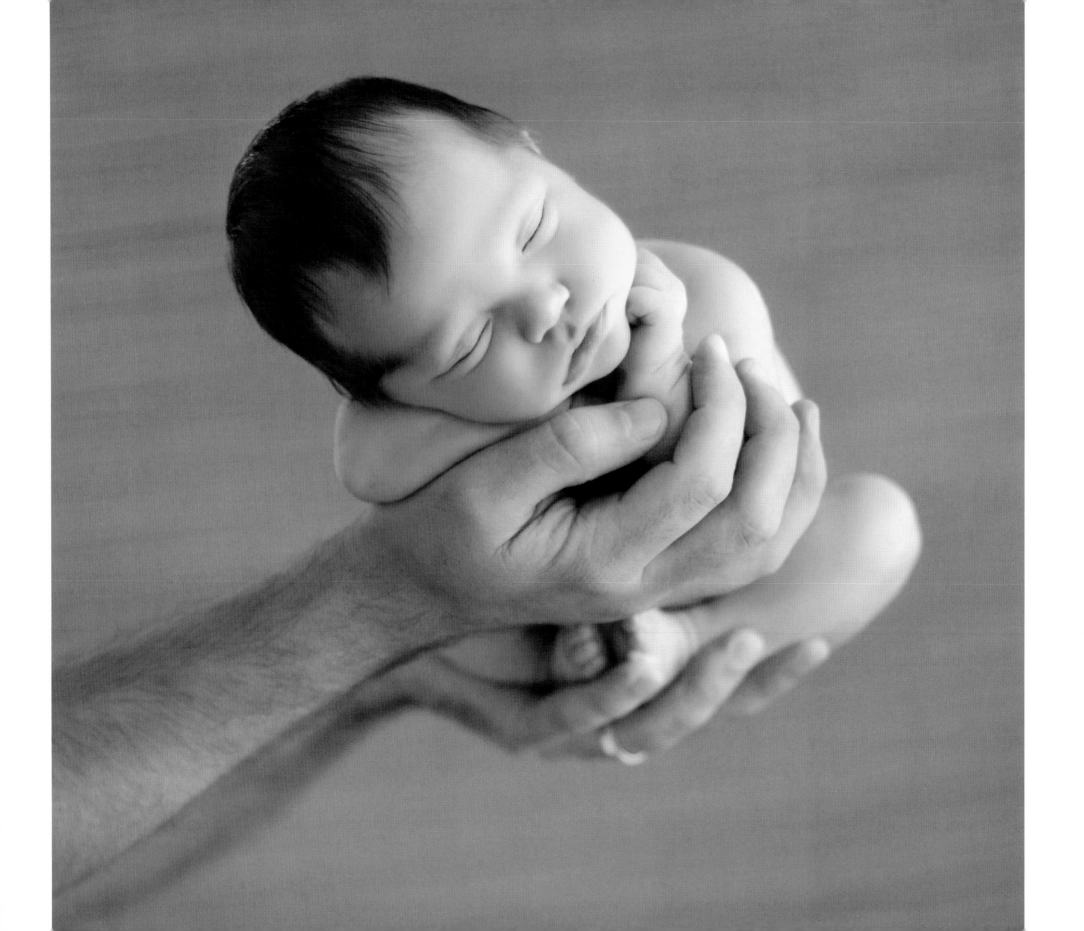

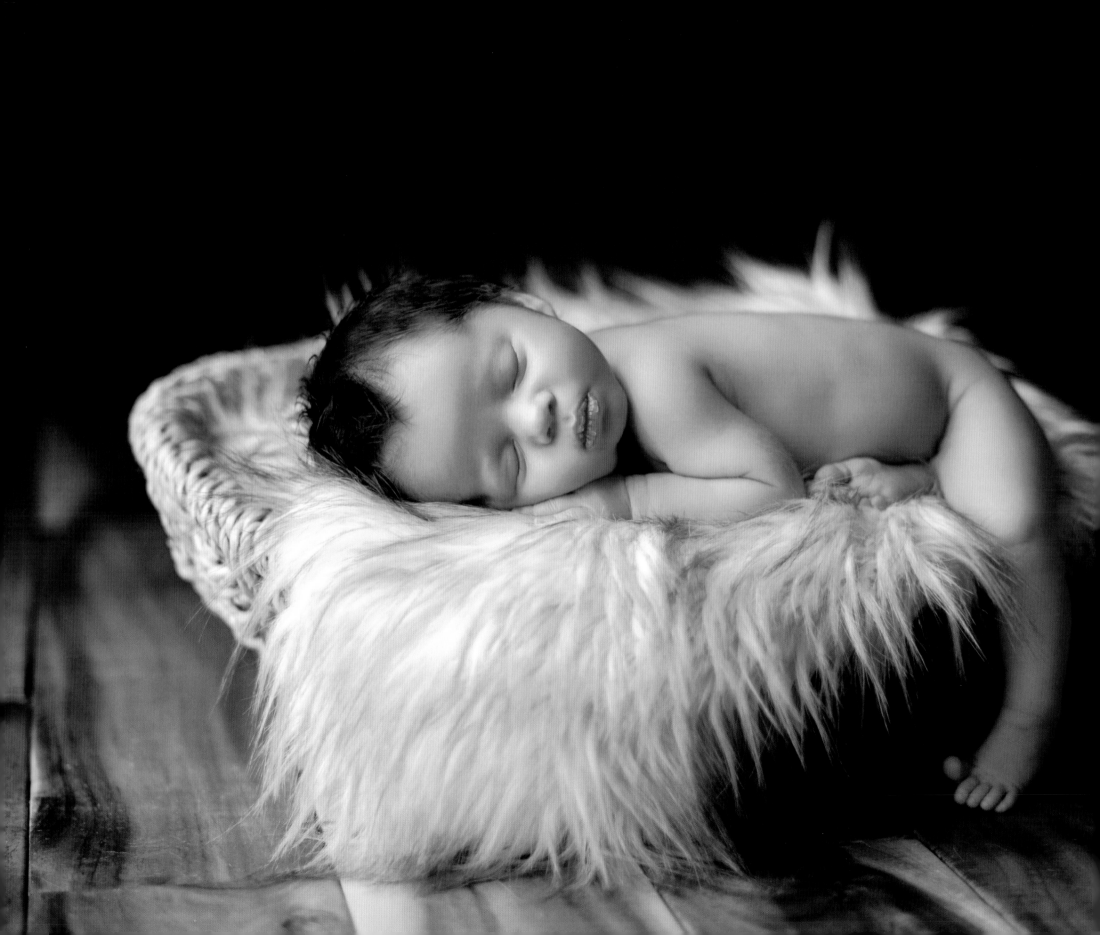

Making the decision to have a child is momentous. It is to decide forever to have your heart go walking around outside your body.

— *Elizabeth Stone*

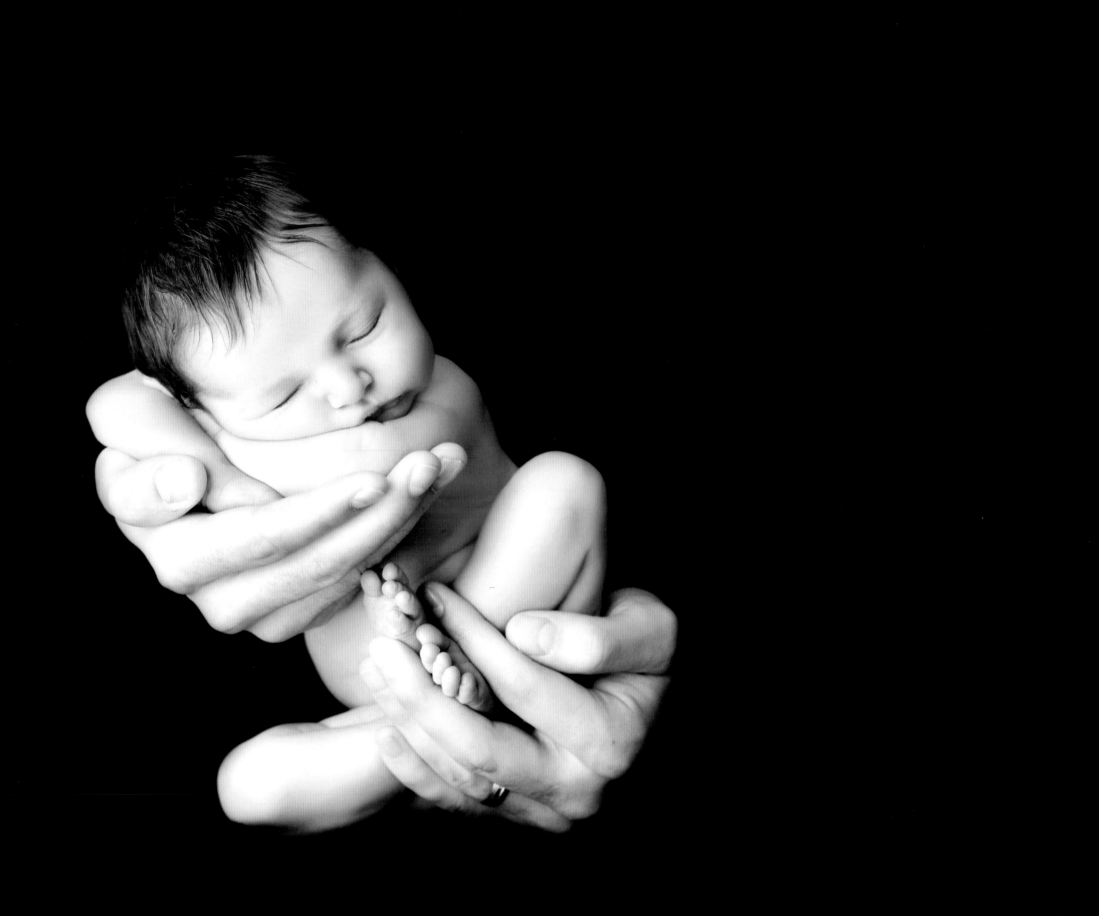

One generation plants the trees;
Another gets the shade.

— *Chinese Proverb*

Where there is great love there are always miracles.

— *Willa Cather*

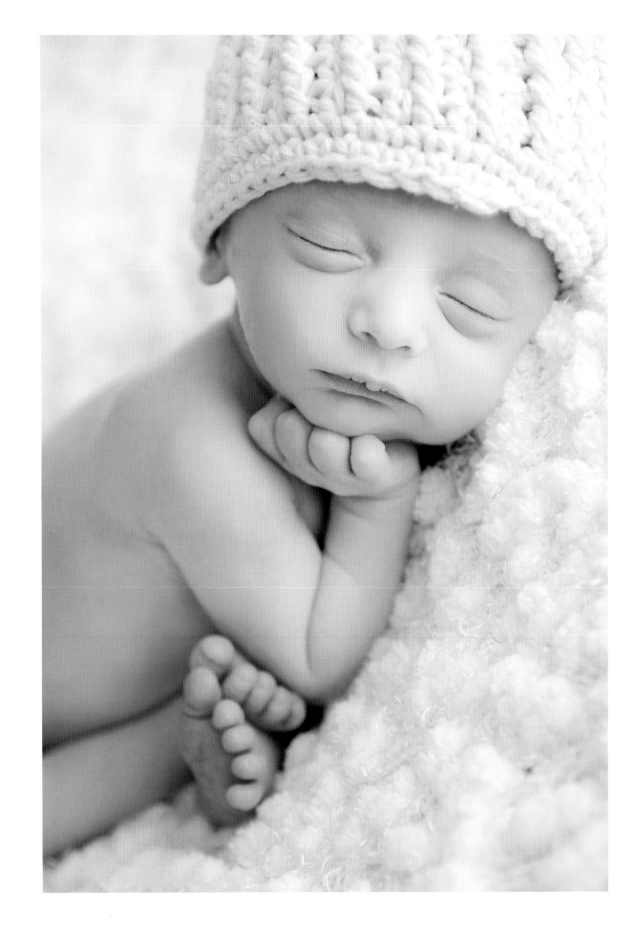

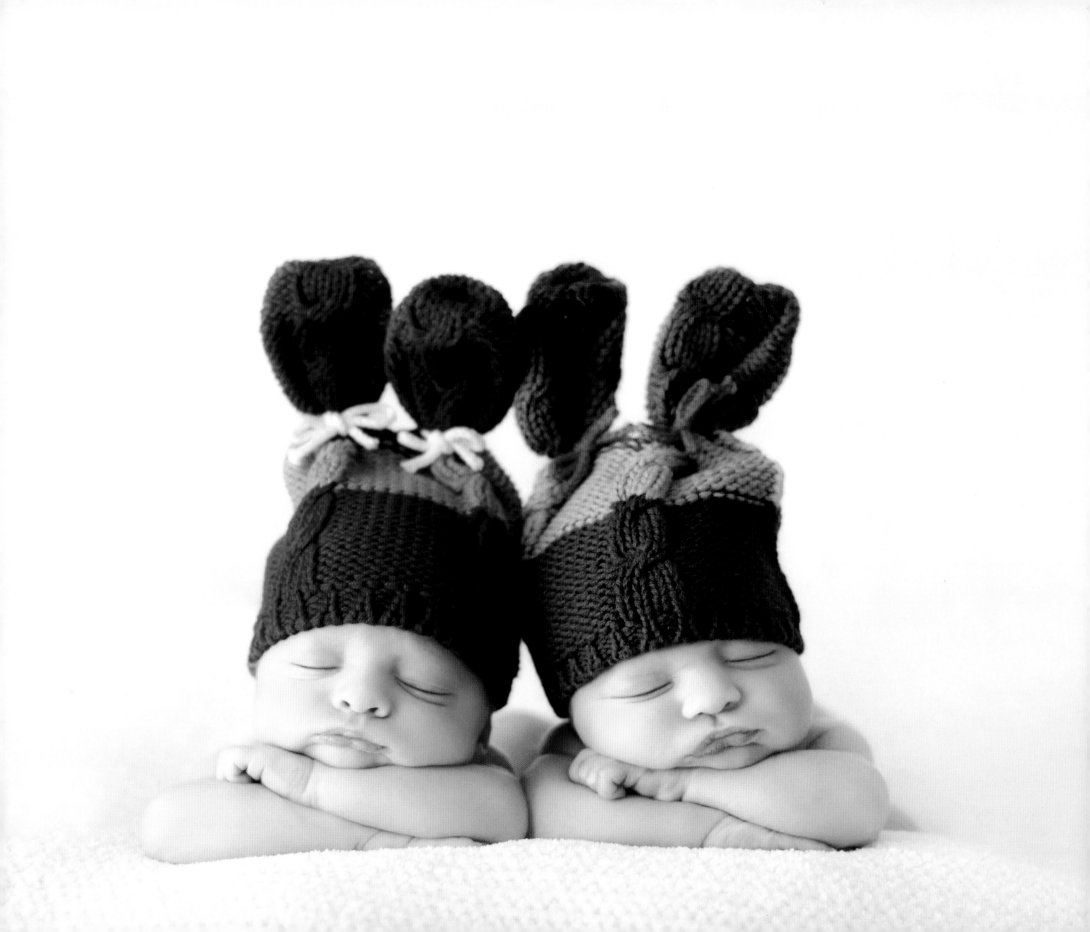

Babies are such a nice way to start people.

— *Don Herold*

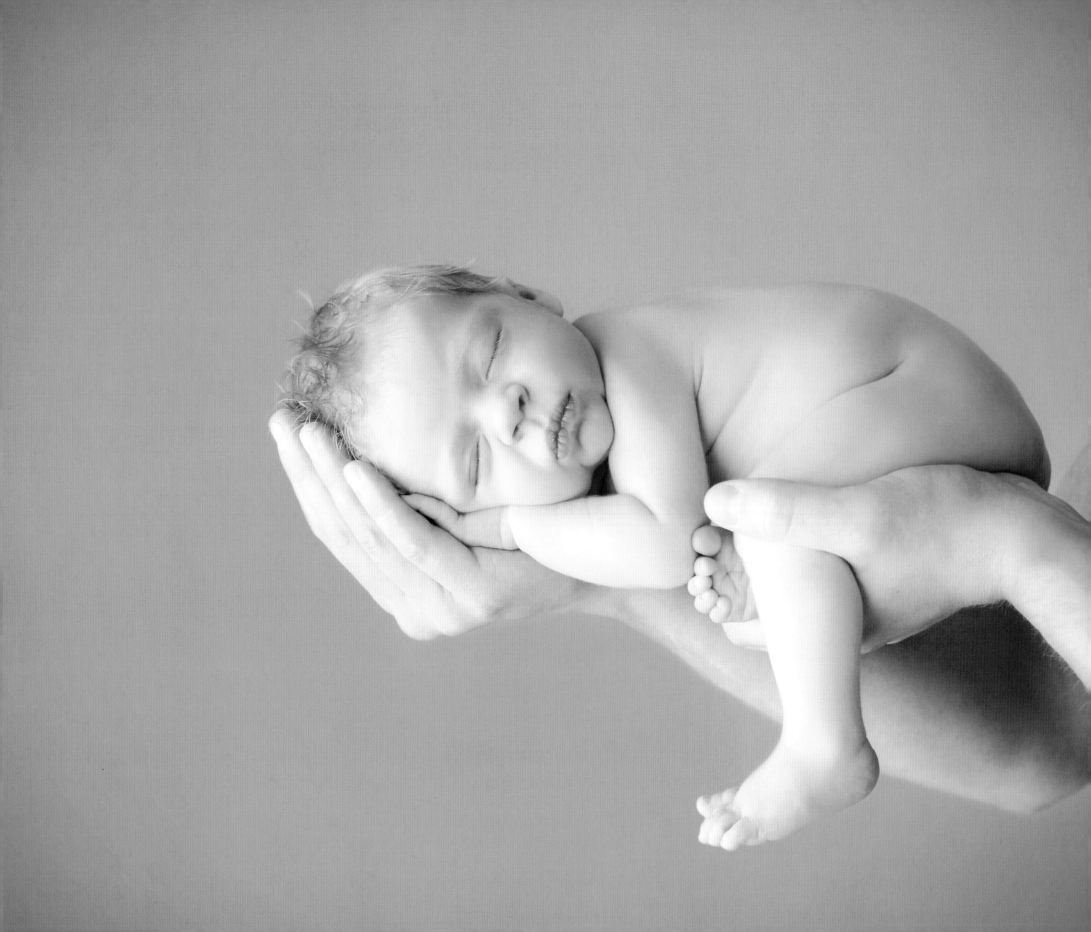

When you have a newborn, every day holds the possibility of a miracle.

— *Anonymous*

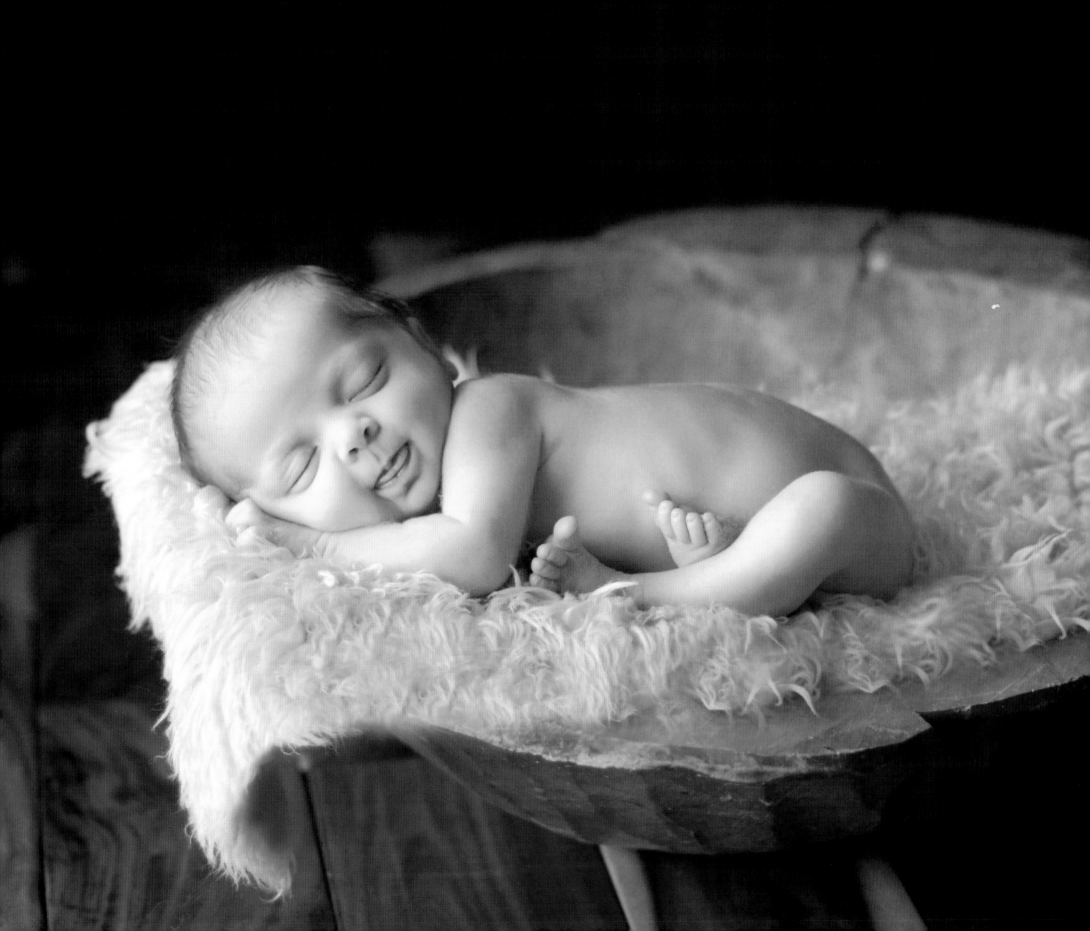

Every child born into the world is a new thought of God, an ever fresh and radiant possibility.

— *Kate Douglas Wiggin*

Happiness is made to be shared.

— *Pierre Corneille*

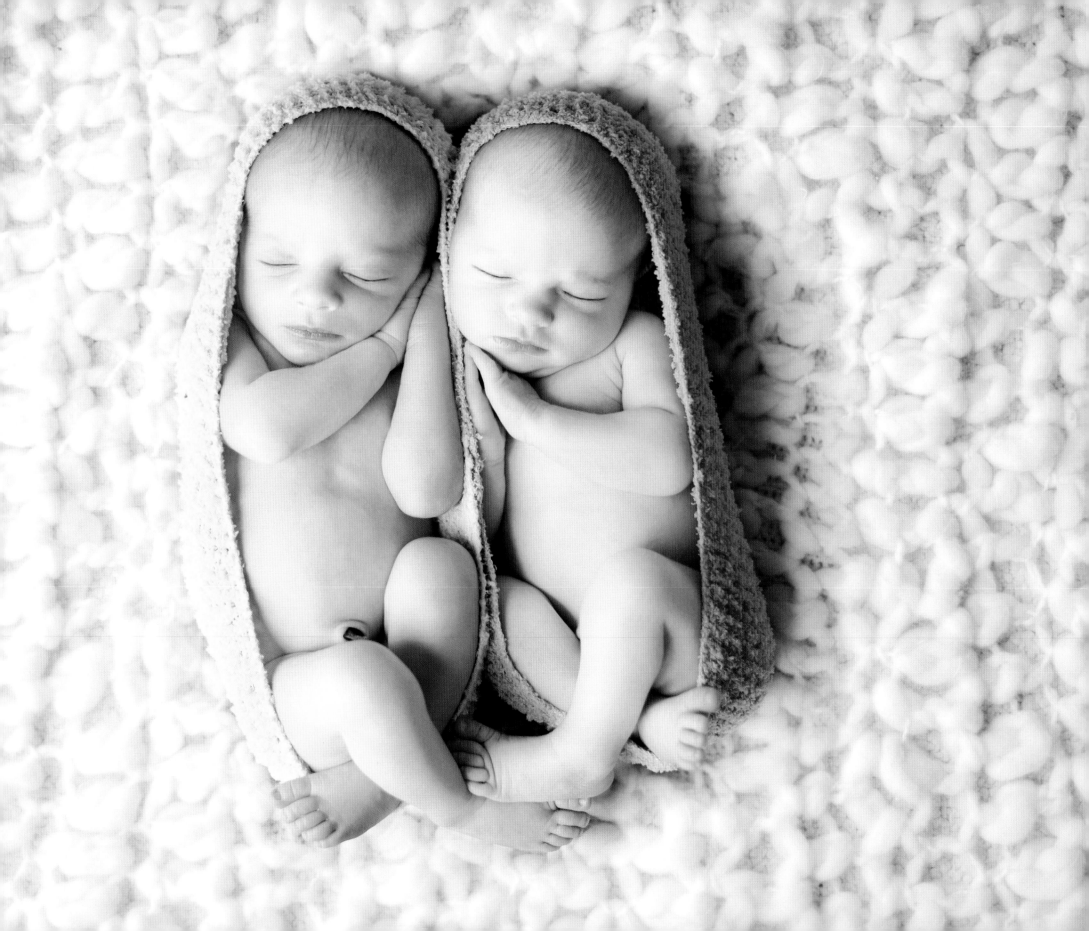

Dreams are the touchstones of our character.

— Henry David Thoreau

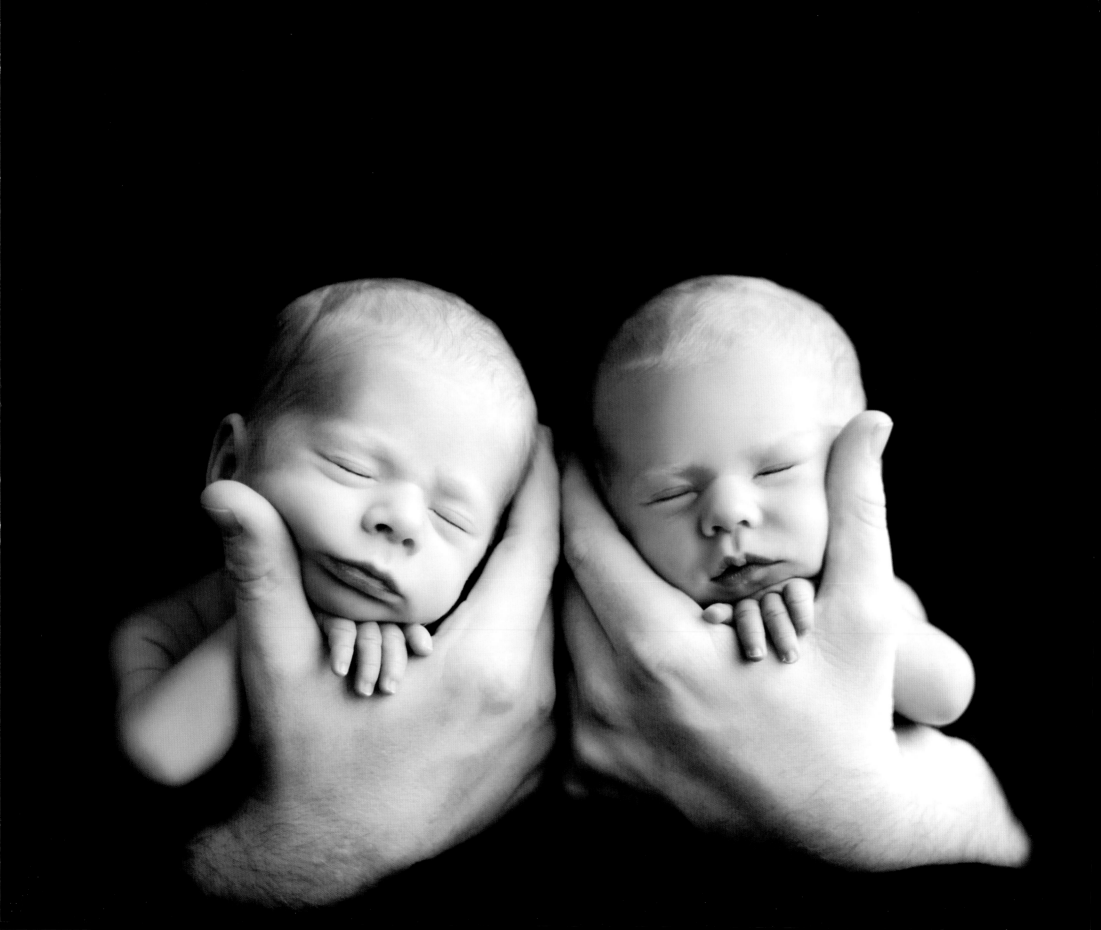

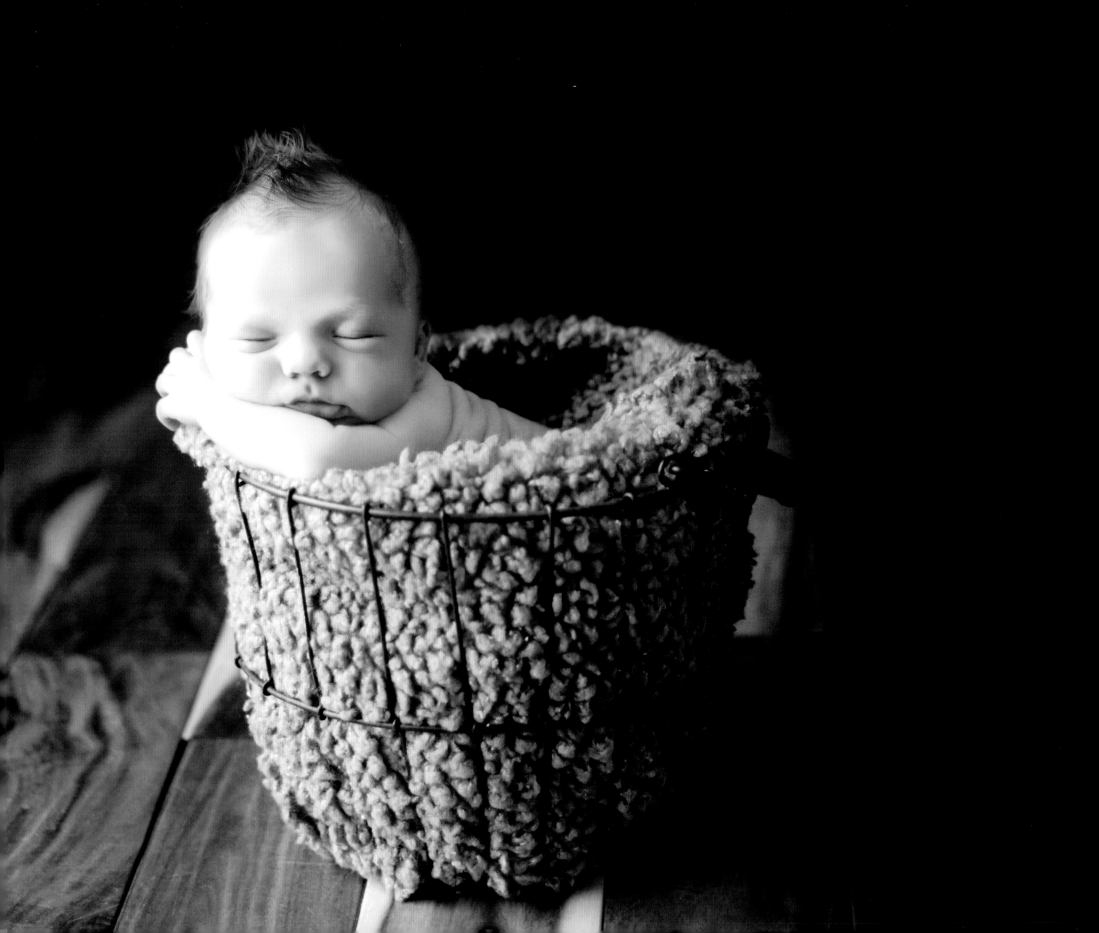

Loving a baby is a circular business . . .
The more you give the more you get
and the more you get the more you feel like giving.

<div align="right">

— *Penelope Leach*

</div>

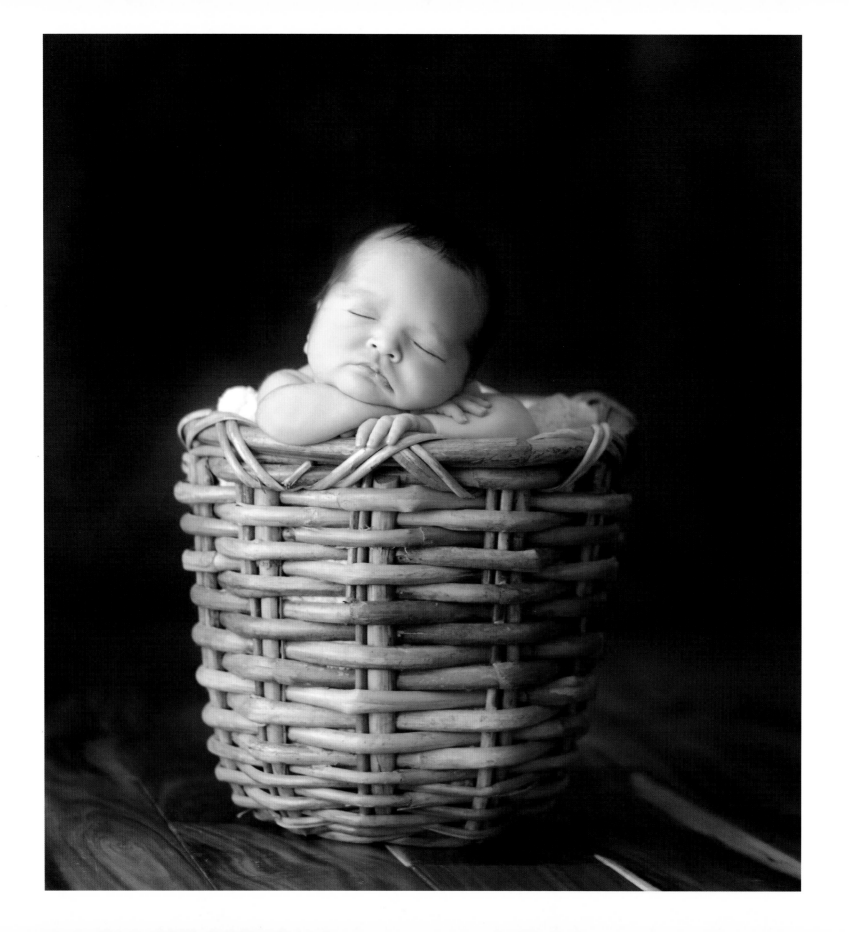

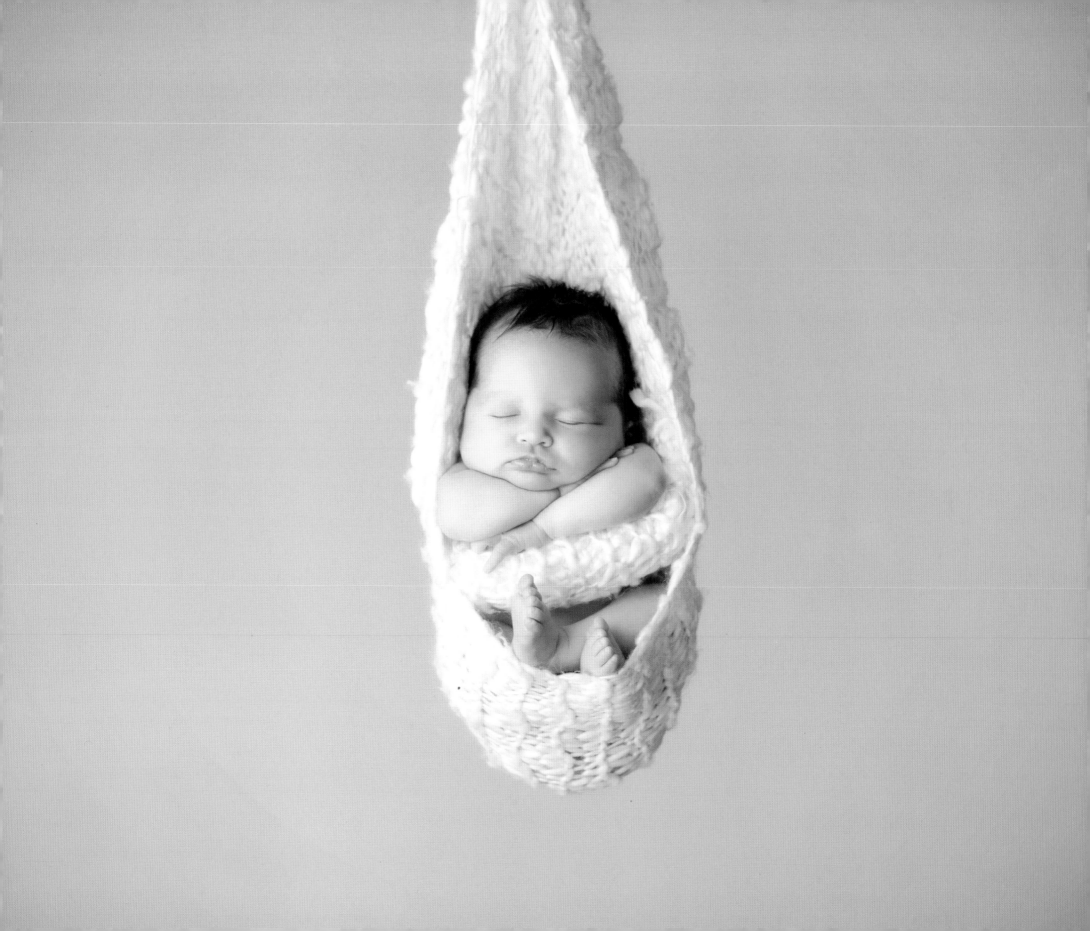

"Sometimes," said Pooh, "the smallest things take up the most room in your heart."

— *A. A. Milne*

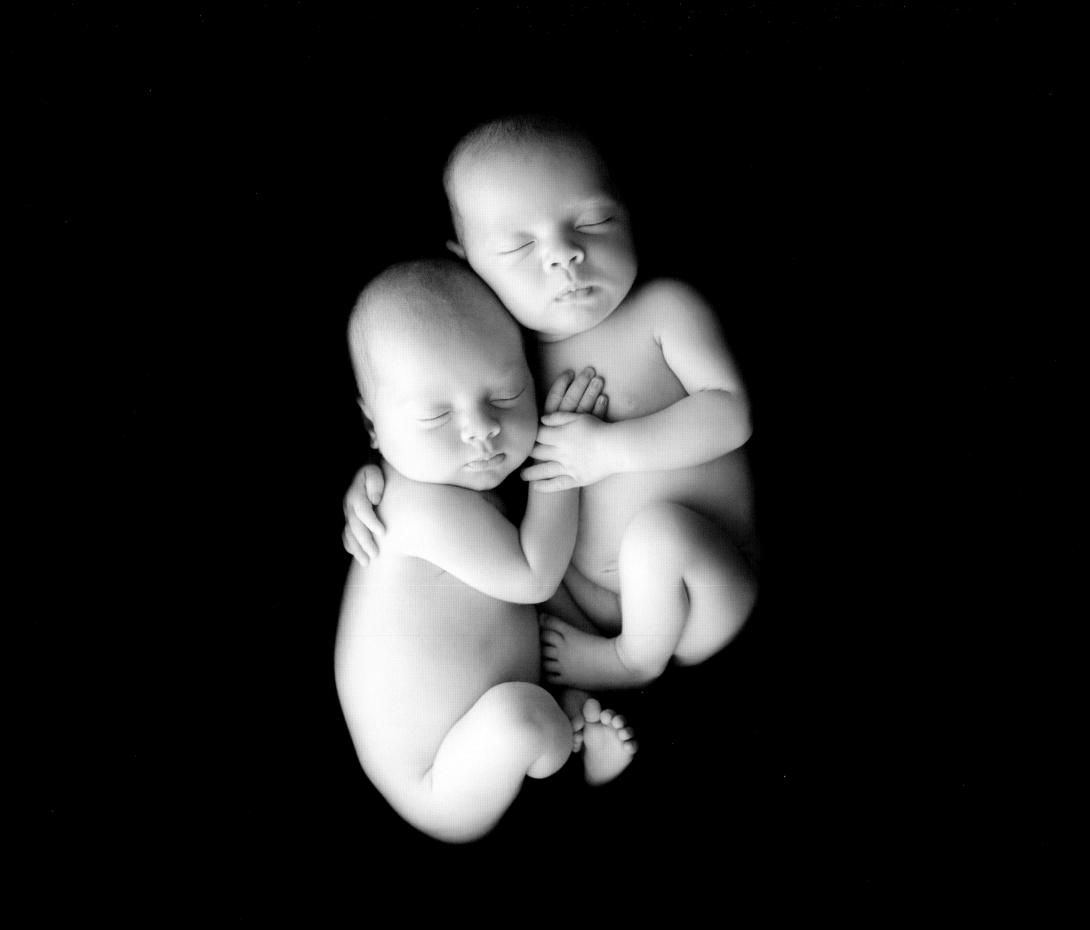

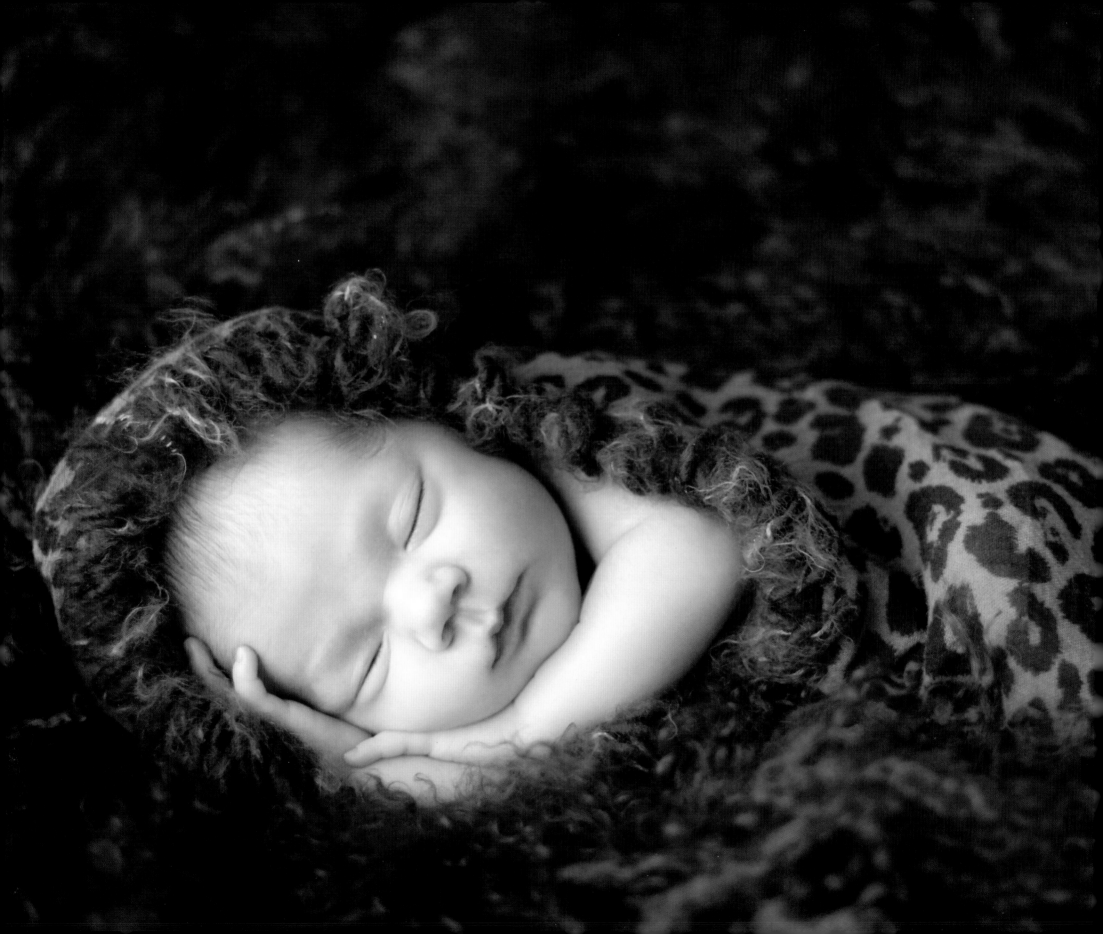

Love is not only the most important ingredient:
it is the only ingredient that really matters.

— Anonymous

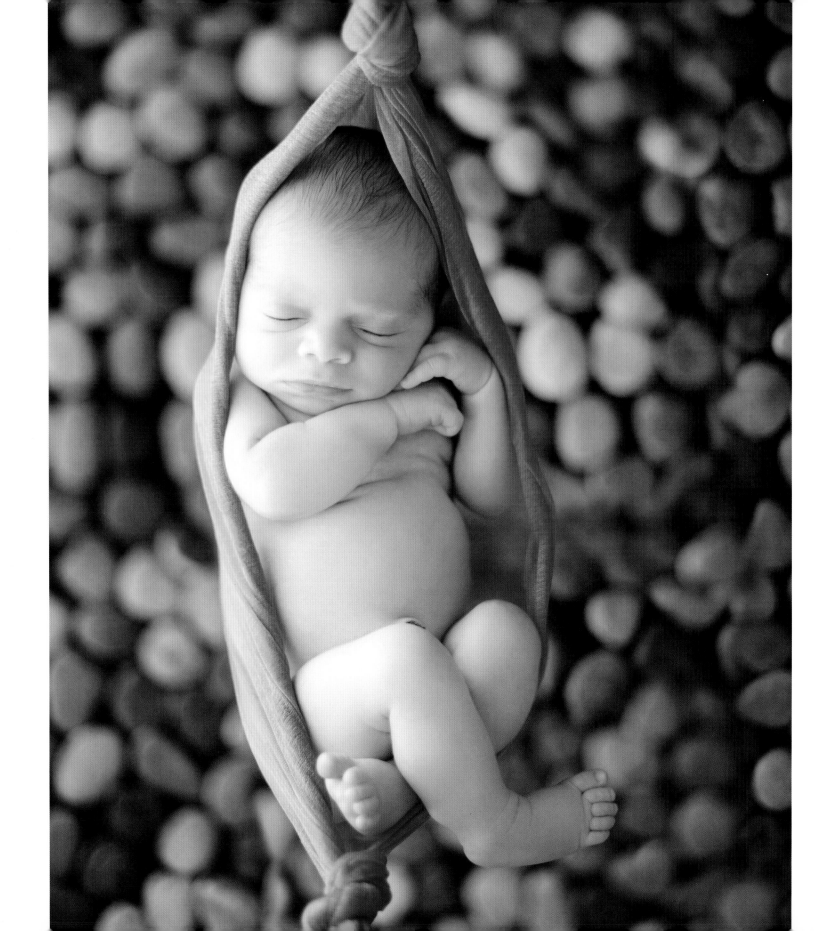

In our life there is a single color, as on an artist's palette, which provides the meaning of life and art. It is the color of love.

— *Marc Chagall*

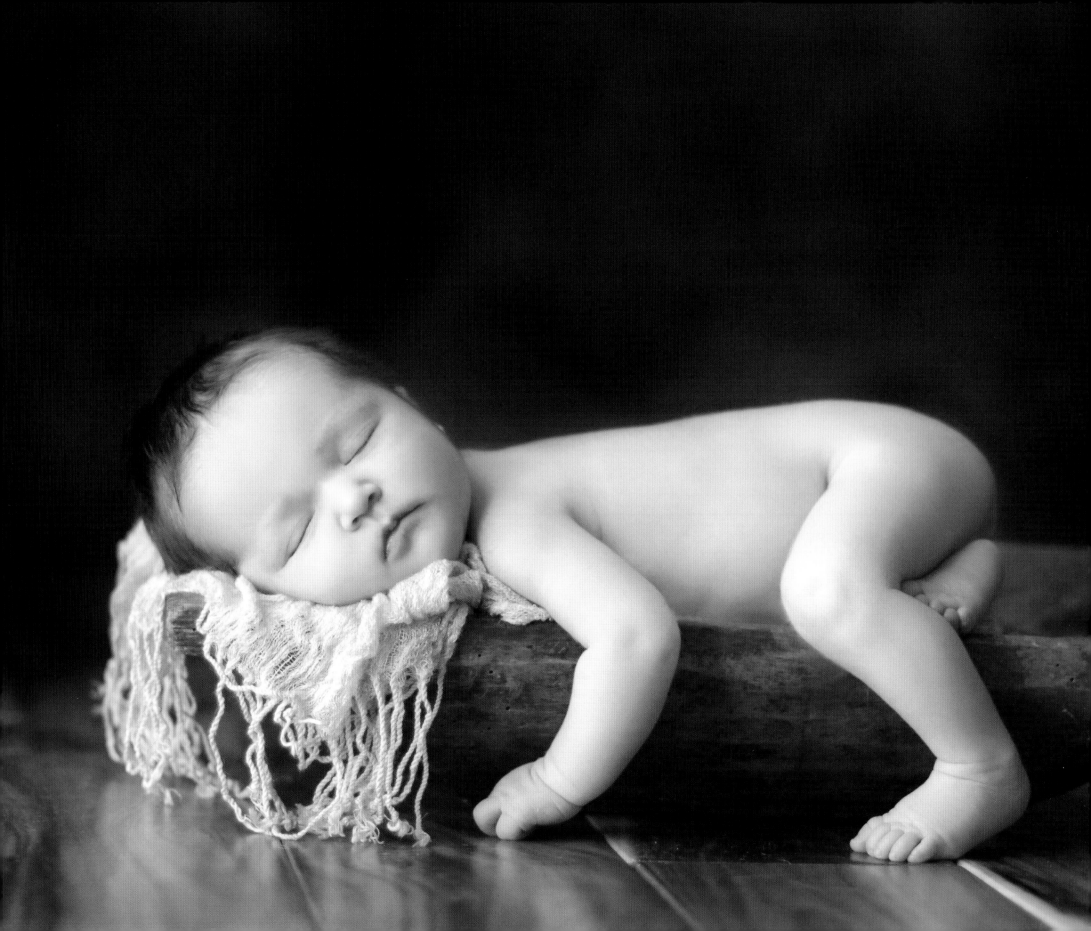

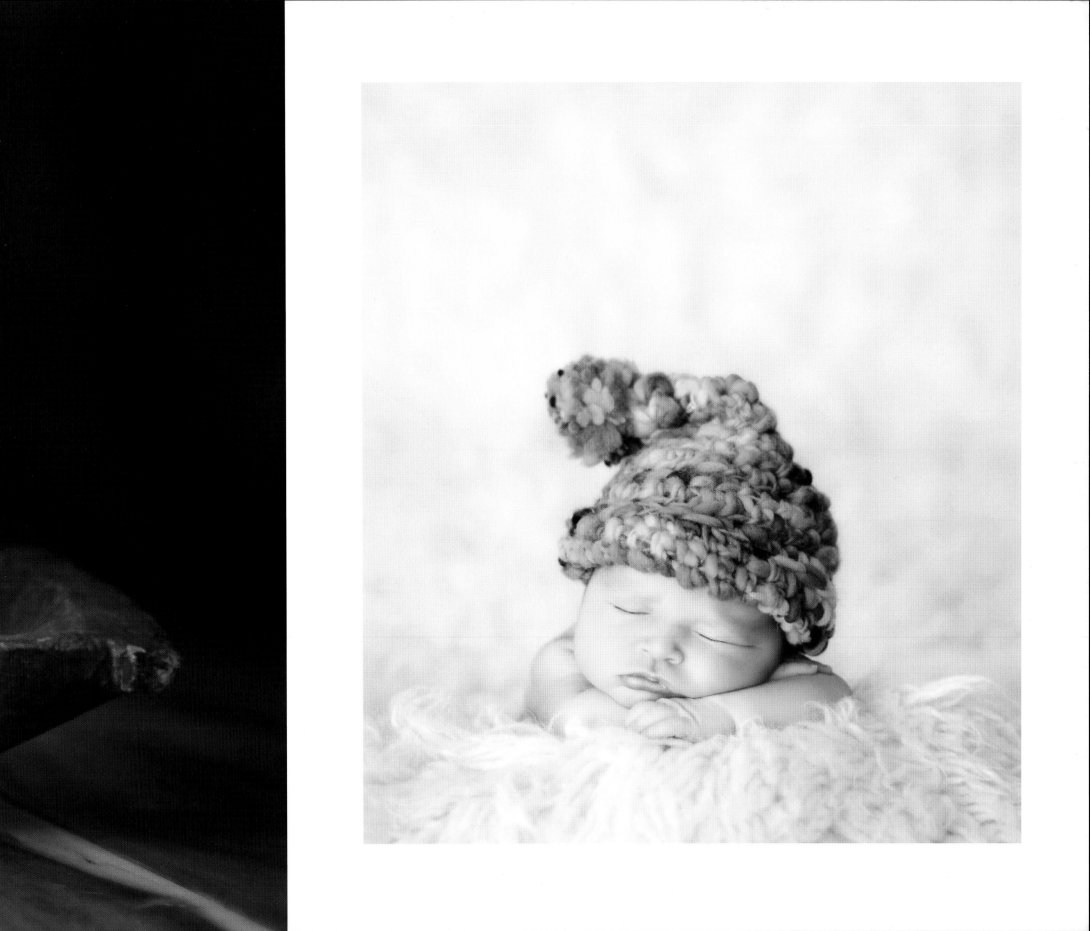

While sleeping, angels have conversations with our souls.

— *Anonymous*

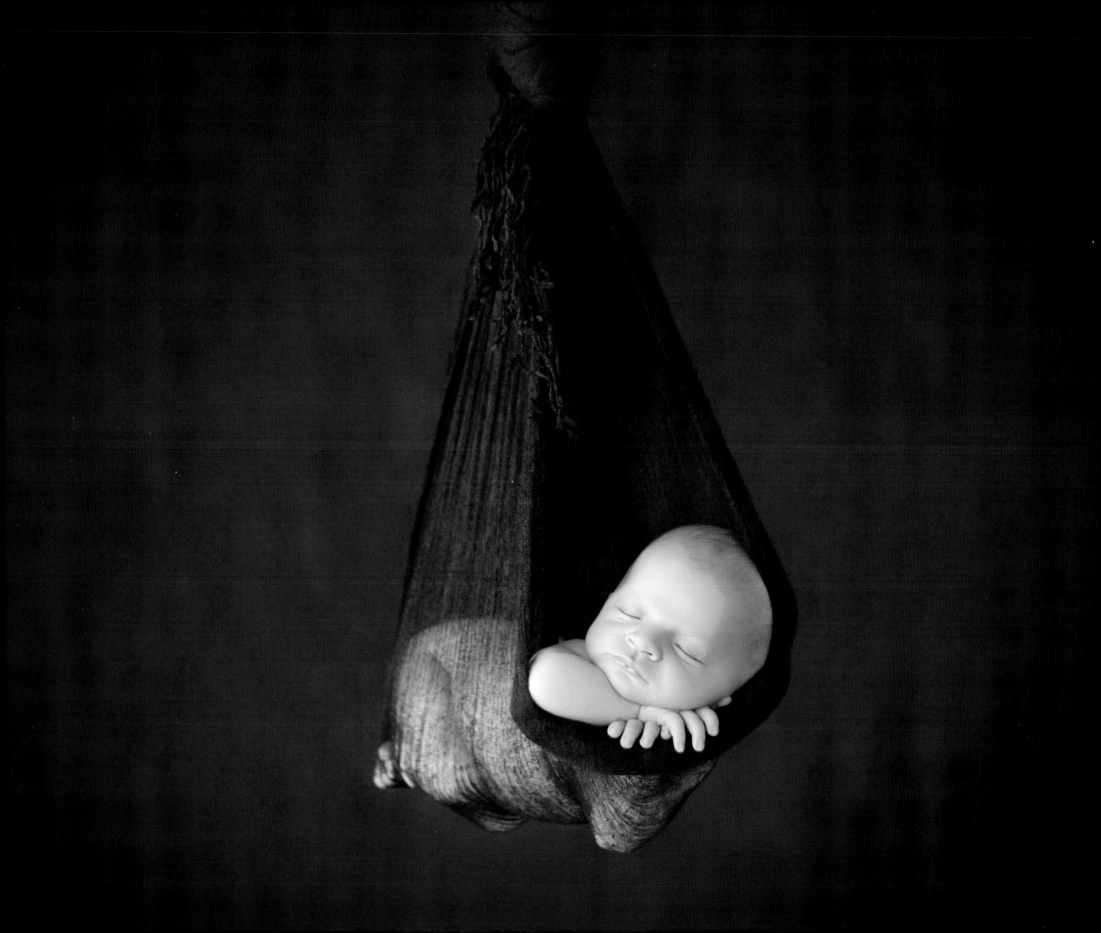

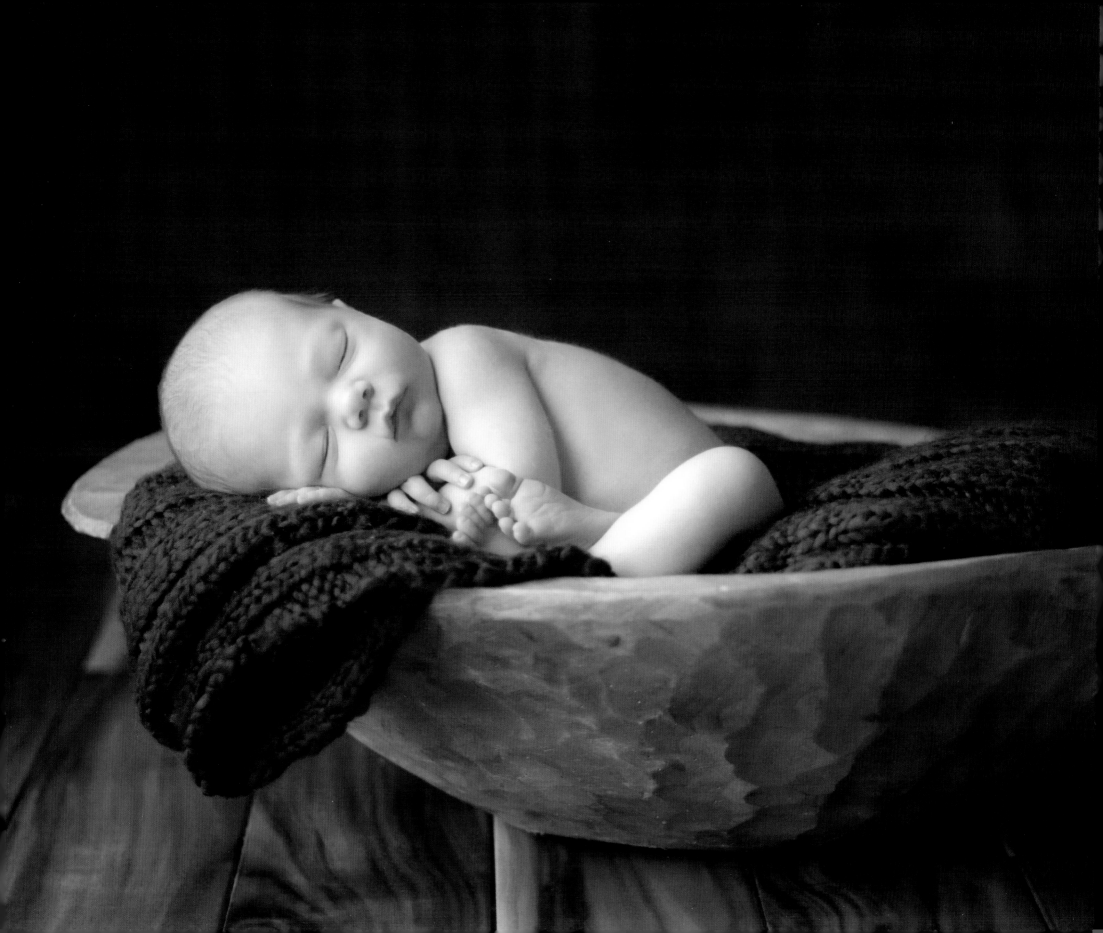

When I approach a child, he inspires in me two sentiments; tenderness for what he is, and respect for what he may become.

— *Louis Pasteur*

Every child begins the world again.

— Henry David Thoreau

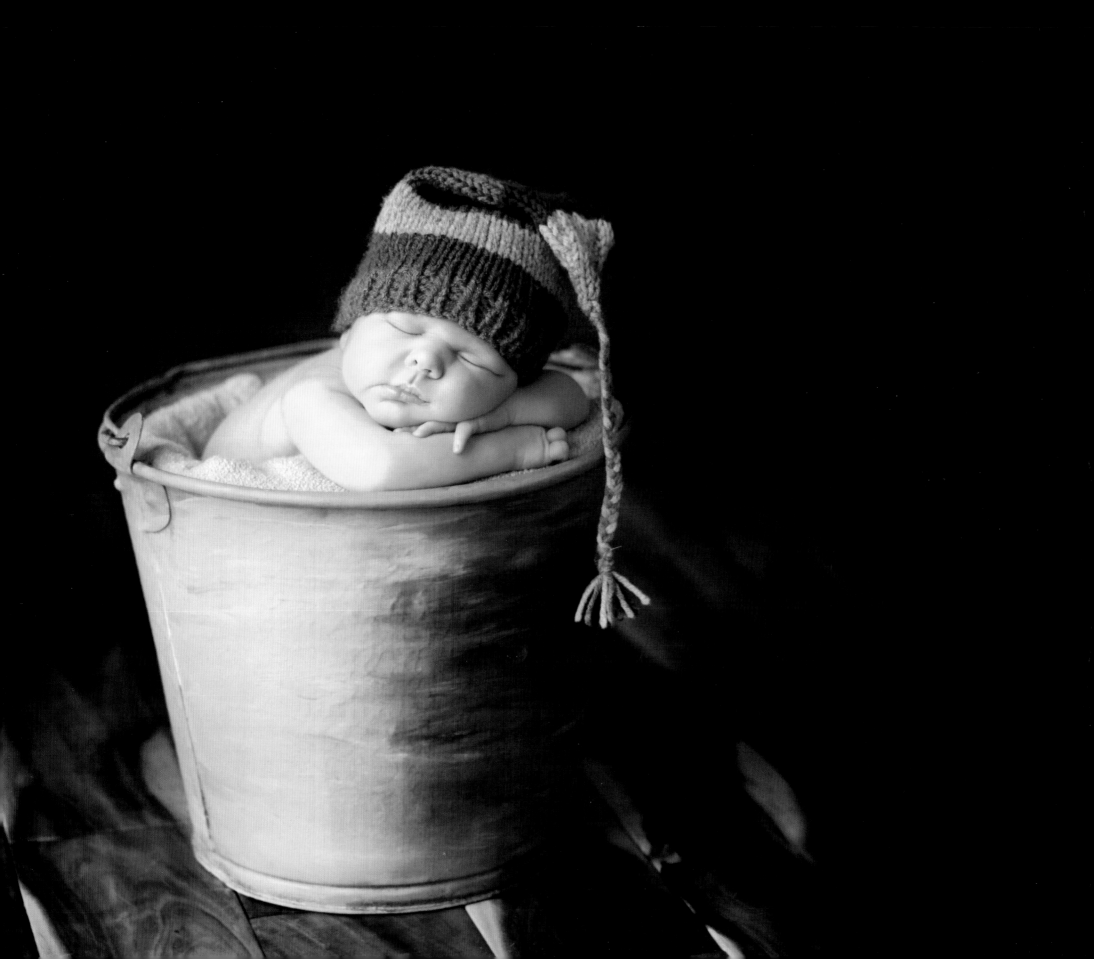